THE
GAMES
WE
PLAYED

LIBRARIES NI
WITHDRAWN FROM STOCK

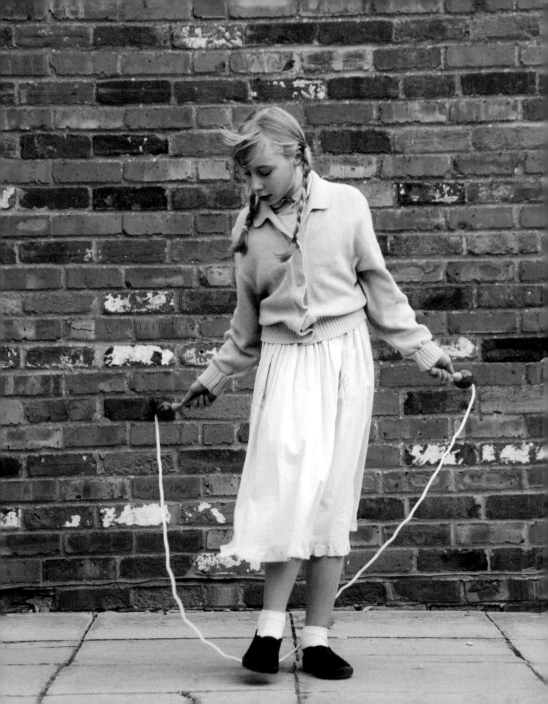

THE GAMES WE PLAYED

EDITED BY
SUSAN KELLEHER

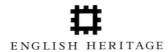

ENGLISH HERITAGE

Published by English Heritage,
NMRC, Kemble Drive, Swindon SN2 2GZ
www.english-heritage.org.uk

Copyright © English Heritage 2007

10 9 8 7 6 5 4 3 2 1

ISBN 978 1 905624 46 1

Product code 51257

A CIP catalogue for this book is available from the British Library

All rights reserved

No part of this publication may be reproduced or transmitted in any
form or by any means, electronic or mechanical, including photocopying,
recording or any information storage or retrieval system, without
permission in writing from the publisher.

Brought to press by Susan Kelleher and René Rodgers
Designed by Fiona Powers
Printed by Oriental Press, Dubai

N E EDUCATION & LIBRARY BOARD	
C400108887	
Bertrams	30.09.07
790.19220941	£9.99
CNL	

Contents

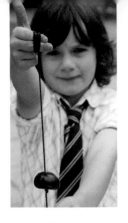

Preface

In the March 2006 issue of *Heritage Today*, English Heritage members were asked to submit their memories of the traditional games they had enjoyed in their childhood. Many people sent in long, interesting letters detailing their favourite games and it has been a fascinating task compiling them into this book.

Everyone wrote of their fond memories of these games recalling that they were simple, energetic and exciting. They range from familiar favourites like 'Hide and Seek' to weird and whacky pastimes like 'Peanut Rolling'! Most of the games described in this book are group games and it is intriguing how the rules and the names vary in different parts of the country. Some games are, however, downright dangerous and modern children should not be encouraged to attempt them. Most are just great fun.

The letters we received gave details of games popular in the period 1920–70, and inevitably there will be many games that have not been included. We'd be pleased to hear of any memories that you have of other favourite games so that maybe these can be included in future editions. In this way we can ensure that these traditional games survive to be enjoyed by future generations.

Susan Kelleher
Editor

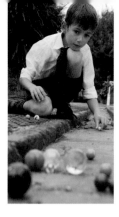

Introduction

It snowed today, a couple of inches, nothing more. The media had been warning us for days about the 'severe weather', insisting we should only venture out if absolutely necessary, and if we were foolhardy enough to try then we should at least take a shovel. My children are 10 years old. They have hardly ever seen snow, having been born into a world that seems to be warming at an alarming rate. Their walk to school was high spirited for once, as they anticipated a day of snowball fights,

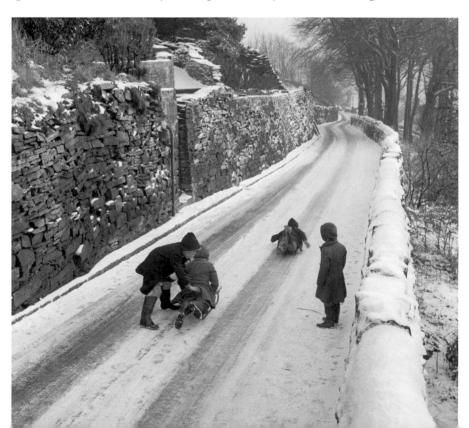

snowmen and unmitigated fun. A few hours later they trudged morosely home through the greying slush. They hadn't been allowed out at playtime they told me, for 'health and safety reasons' and most of the snow had melted by lunchtime anyway.

Today brought home to me all the reasons why I wanted to commission this book. Like most people over the age of 40 I'm morbidly nostalgic. Even snow it seems isn't like it used to be. I'm particularly nostalgic about childhood. All adults have a tendency, I'm sure, to don the rose-tinted spectacles when looking back on the halcyon days of their younger years. My memories are of endless summer holidays filled with games of football with cricket scores, hide and seek that lasted for hours and covered miles, simple pleasures like blowing bubbles, climbing trees or playing 'Tag'.

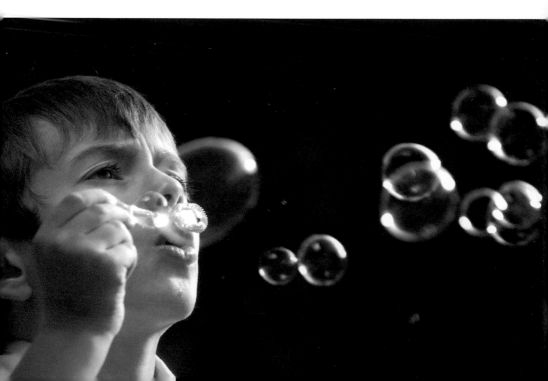

We roamed feral, the countryside was our playground, home was somewhere for bolting down dinner before going out to play again. Of course there were fads and crazes, as there are today – frisbees, clackers and skateboards all came and went, but the games we enjoyed most were the ones which didn't need expensive equipment. 'British Bulldog', 'Finger Thumb and Rusty Bum', 'Kick Can' kept us entertained for hours and cost us nothing except a few grazed knees. We made camps, tree houses and swings in the woods; dug tunnels and holes for no apparent reason; built trolleys out of old prams. And we did all this on our own. We made the rules, picked the teams, stopped the fights, all without the interference of our parents. In today's society we would probably have all been branded as out of control and slapped with ASBOs (admittedly we did indulge in the occasional hedge hopping, apple scrumping and knock door-run, which we knew was wrong, but oh, the adrenaline rush of the chase!)

Our overprotected 21st-century children are missing out on the freedom children enjoyed only a generation ago. Sure they still play, many have more toys than the average playgroup, but everything today, it seems, has to be supervised. They are ferried from one organised club to another, football skills are taught in coaching schools rather than acquired by endless hours spent kicking a ball against a wall. Today's 8-year-old can dance, swim and may even speak a second language. But can they play hopscotch?

The reasons for this are many and complex – today's parents are much more anxious about letting children out of their sight and prefer to cocoon them in the apparent safety of the home; the exponential rise of the car means that the street is no longer a safe place to play games like 'Kerb'; many playing fields have been sold off for development and schools fear litigious parents. But the biggest

factor must be the all pervasive presence of television and computers. Dedicated children's channels mean that children of any age can watch television programmes any time of day, and they have an endless supply of videos and DVDs to watch and re-watch. When I was a child, the best we could hope for was an hour of television after school and dubbed black-and-white Czechoslovakian imports in the summer holidays. We probably would have watched these all day, but we didn't have that choice. If today's kids do eventually get bored of the endless diet of television then they have the virtual reality offered by video games, handheld consuls and computers. Ironically the latest technology simulates playing real games without ever having to leave the front room. And the internet offers the chance to make friends without ever having to meet them.

It is our duty as parents and grandparents to give our children back some of the freedoms which we all enjoyed, yet which in today's culture of paralysing fear, we are too scared to grant to our kids. Go on, tell your children to 'Go out and play.' I dare you!

Rob Richardson
Head of Publishing, English Heritage
February 2007

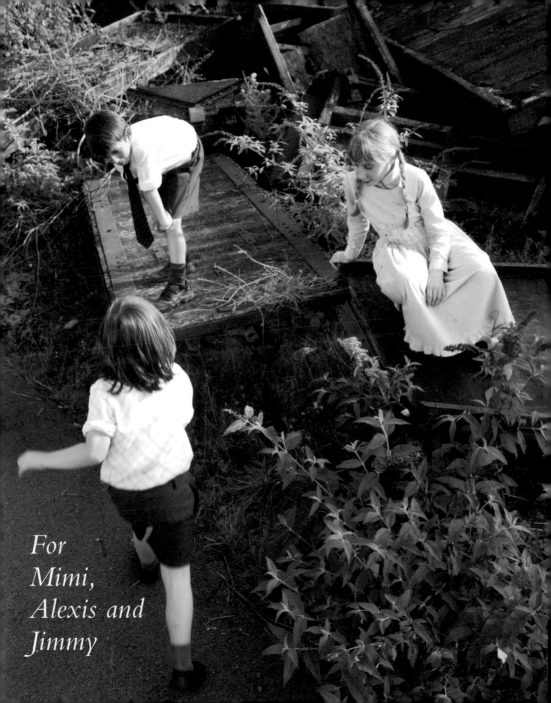

*For
Mimi,
Alexis and
Jimmy*

Adder's Nest

A trial of strength and ingenuity! A group of children clasp hands and form a circle round a particular object such as a tin can, school cap, stone, drain etc. They walk or skip round first of all, sometimes reciting a special rhyme like:

Five little sausages sizzling in the pan,
One went pop and the others went BANG!

On the word 'Bang', or at any other given signal, they push and jostle their neighbours (without letting go of their hands) to try and make someone touch the object in the middle. Anyone touching it has been 'poisoned' by the 'adder' and is out of the game. As each person is eliminated, the game gets to be more of a struggle and the winner is often exhausted at the end!

Also known as: Bonnety; Chimney Pots; Poison

Angler and Fish

One player is chosen to be the 'angler' and he is then blindfolded and given a long piece of string. The rest of the players choose a type of fish for each person and form a circle round the angler. The angler throws out his 'line' and one of the players chooses to grab it; the angler then has to guess which fish he has caught. If he is correct, he joins the circle and the 'fish' becomes the angler.

'My grandchildren don't play games like we did and I think they miss out terribly.' (Lindy McKinnel, Lymm, Cheshire)

Assassin

This game needs a large group of about ten children. One is selected to be the 'detective' and he has to stand away from the group while the rest go into a huddle to decide who is going to be the 'murderer'. The detective then rejoins the group and the murderer has to 'kill' people in the group by surreptitiously winking at them. Anyone winked at has to leave the circle and the object of the game is for the detective to work out which child is the murderer before everyone else is 'dead'!

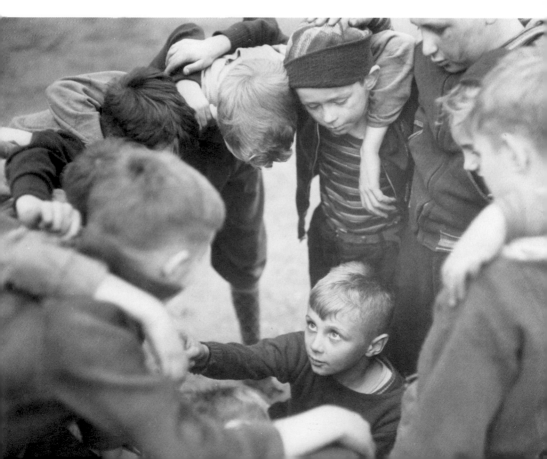

Bad Eggs

One person from the group is given a tennis ball and they stand away from the rest of the players. The rest then choose a particular subject, for example flowers, colours etc, and select a flower, colour or whatever for each player, as well as one for the person with the ball. The chosen names are then called out; the person with the ball chooses one, shouts it out and at the same time throws the ball into the air. Whoever has that name has to dash out and catch the ball while the rest run away as far as possible. As soon as the ball is caught, the player catching it yells out 'Stop!' and everyone has to stand stock still. The player with the ball can then take up to three strides towards the person nearest to them and attempt to hit them below the knee with the ball. If they succeed, the person hit stands apart for the next round. If they miss, they have to stand out for the next round and someone else is given the ball.

Ball in Cap

In the 1940s and 1950s it was customary for boys to wear school caps as part of their uniform. Of course, they found all sorts of other uses for their caps – including this game! The players place their caps in a line against a wall and then stand at some distance away taking turns trying to roll a soft ball into any cap except their own. When the ball goes inside a cap, the owner of that cap has to rush across, take up the ball and throw it at one of the other players. If he is successful in hitting that player, a stone is put in that person's cap; if not, a stone is placed in his. When a certain number of stones (usually 5) has been put in a cap, the owner is out of the game.

Big Ship Sails on the Alley Alley O

A popular singing game that reputedly dates from the opening of the Manchester Ship Canal in 1894. It's an appealing, if unlikely, origin to this game which involves a relatively large group of players in a game of contortion. The players all hold hands in a line and the last person puts their free hand against a fence or wall to form an arch. The first person leads the line under the arch and everyone sings:

The big ship sails on the alley alley O,
The alley alley O, the alley alley O,
The big ship sails on the alley alley O,
On the last day of September.

We all dip our hands in the deep blue sea,
The deep blue sea, the deep blue sea,
We all dip our hands in the deep blue sea,
On the last day of September.

The captain says, 'This will never never do,
Never never do, never never do!'
The captain says, 'This will never never do!'
On the last day of September.

As the final person goes through the arch, the one making the arch is pulled round to face the other way. The leader then takes the line through the gap between the person making the arch and the player next to her and so on until everyone eventually ends up facing the other way with their arms crossed. The ends of the line then join up in a circle, let go of their hands and wag their fingers on the lines 'This will never never do!'

Variations: Numerous – and whether it's September, December or indeed any other month or date is open to debate!

Bingo

The delightfully named Bobby Bingo was apparently a character in a popular 18th-century comic song.

A group of children select one person to stand in the middle, and then often blindfold them. The rest of the group link hands and dance around singing:

There was a farmer had a dog,
And Bingo was his name-o,
B-I-N-G-O, B-I-N-G-O, B-I-N-G-O,
His name was Bobby Bingo!

The spelling out of the name in the third line is done with much gusto and, on the first shout of 'B', the person in the middle points to someone in the ring. As each letter is spelt out, the next person in the circle is pointed to and so on round the ring. The person being pointed to on the final 'O' goes into the middle to join the pointer. The game continues until the circle gets too small!

Bird Catching

Three areas of the playground are marked out and designated as the 'Nest', the 'Wood' and the 'Cage'. One player is selected to be 'Mother Bird' and stands in the Nest; one player becomes the 'Bird Catcher' and takes up a position between the Nest and the Woods where the rest of the players stand. Mother Bird calls her family to the Nest one by one and they have to try and get there without being touched by the Bird Catcher. Anyone caught is put in the Cage and has to stay there until the end of the game when there are no more 'birds' left in the Wood.

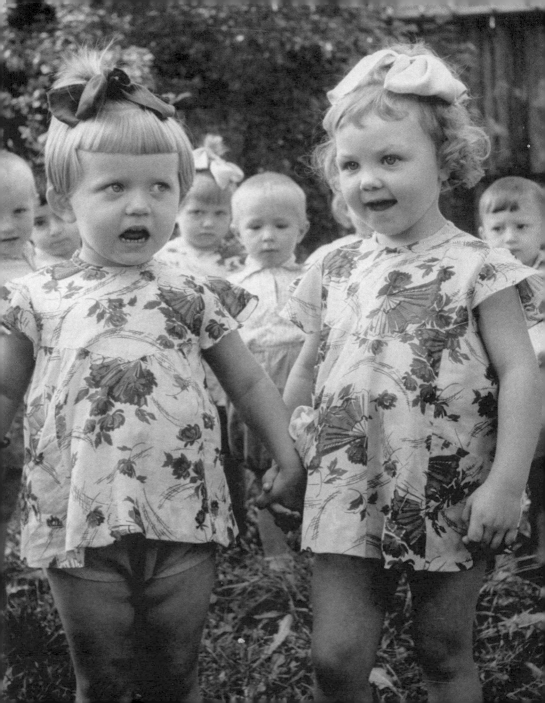

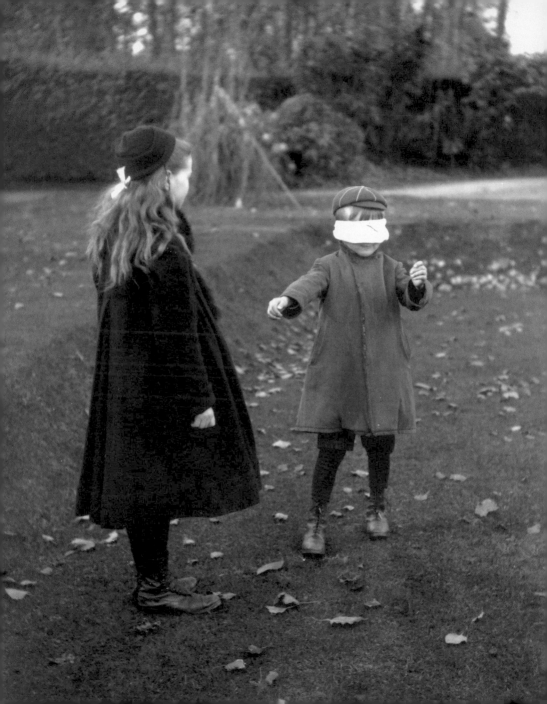

Blind Man's Buff

A favourite game that can be played indoors or out. It has been enjoyed for centuries and probably has very ancient origins as a similar game was known 2,000 years ago in Greece.

In more recent times, the game was particularly popular in the Victorian era, and also had a great revival in the 1950s when it was invariably played at children's birthday parties after everyone had had their fill of jelly (in those fluted paper dishes) and Neapolitan ice cream (pink, white and brown (or green) stripes).

One child is blindfolded and spun round several times to disorientate them. The rest of the group remain still while the blindfolded child holds their hands out in front of them until they bump into someone. They then have to guess who the person is by touching their face and clothes. If they guess correctly the blindfold is removed and someone else is blindfolded. If, despite clues from the rest of the players, they still fail, they have to remain as the 'blind man'.

Variations: Sometimes players change clothes to confuse the 'blind man' even more.

Also known as: Biggley; Blind-Bucky-Davy; Blind Harry; Blind-Merry-Mopsey; Blind Sim; Hoodle-cum-Blind

'I dreaded being picked to be the "blind man" as they always used to twizzle you round so many times that you felt really dizzy.'
(Carole Beaty, Chichester, West Sussex)

British Bulldog

A rather rough (but extremely popular!) game best played on a soft surface with a lot of people. Two areas of 'safety' are marked out at some distance apart and one person is appointed 'Catcher'. The rest of the players divide into two teams, each one standing in an area of safety. The object of the game is for the teams to run across to the other area of safety without being caught. However, a mere touch on the shoulder as in Tag is not enough to be caught. Instead the Catcher lifts his prey off the ground shouting, 'British bulldog, one, two, three!' A struggle ensues and, if the caught player can break loose before the word 'three', they are free to rejoin the game. If not she either stays and helps the Catcher or is out of the game.

Variations: There are all sorts of ways of catching players — some a lot more violent than others!

'At my junior school the British Bulldog season began as soon as we were allowed back on the grass after the winter, and we must have played most lunchtimes. Usually there was a huge group of us; I don't remember anyone in particular being in charge, we just organised ourselves with a sort of herd instinct. As soon as there were more than a handful of people being 'It' the game turned into a giant scrum and no punches were pulled. All the girls wore shorts under their skirts to avoid the worst of the indignities that came with the game, but we all ended up bruised and with skin and clothes covered in grass stains. Making it to the other side of the field unscathed or being wrestled to the ground were equally exciting prospects and the game was addictive!'
(Adèle Campbell, Swindon, Wiltshire)

Broken Bottles

Several people stand in a circle and throw a tennis ball to each other. If the ball is dropped, that person has to go down onto one knee. If they catch the ball the next time it comes round, they can stand up again – if not, they have to go down onto two knees to try and catch the ball. If they still miss they have to try to catch the ball with one hand while kneeling, then two hands sitting, then one hand sitting, then two hands lying down, then one hand lying down – before being finally out.

Also known as: Three Lives

Buzz

A group of players sit in a circle and start counting in turn. When the number seven or any multiple of seven occurs the word 'buzz' is said. Anyone getting it wrong is out of the game. A good game for learning your seven-times table!

Variations: Other numbers and their multiples can be given different names.

Cannon

Two teams toss a coin (or do some other selection procedure) to decide which side will be the 'in' team. Three sticks about 6–8in long are set up against a wall and then a fourth stick is put across as a bail. The 'in' team take turns at throwing a tennis ball at the sticks to knock them down. If a hit is made, the 'in' team scatter (keeping within an agreed boundary) while the fielding team grab the ball and chase the 'in' team trying to hit any of them with the ball. If contact is made, that person is 'dead' and out of the game. The 'in' team have to try and rebuild the sticks although they are then dangerously exposed and likely to be caught and hit with the ball. If the sticks are assembled successfully, the 'in' team have another turn, but if all members of the 'in' team are caught then the other team has a go.

'It was a very exciting and physical game as the ball was thrown with great force and no mercy.'
(Christopher Heath, Wolverhampton)

Variations: Tin cans can be used instead of sticks. This adds difficulty to the game as the cans tend to spread over a wider area when they are hit and are more difficult to reassemble.

Capture the Flag

A popular and exciting game best played with a large number of people. Two leaders are selected and they choose their teams, an area to be their territory and a 'home' or 'base'. Each team has a 'flag'

which is put in their territory in as inaccessible a position as possible. The object of the game is to capture the flag of the rival team, but anyone venturing into enemy territory can be caught by being touched on the shoulder. They are taken to base where they are kept prisoner until rescued by their team members. This has to be done before another attempt can be made to steal the flag. Tactics are all important and players can choose to make sorties into the rival camp individually or in groups.

'I remember playing the game one summer with at least 20 players on each team and quite large territories – with that many people to keep an eye on, crossing enemy lines to steal the flag was a real challenge. But it was such fun – I sometimes wish I could play it as an adult!' (René Rodgers, Bristol, Virginia, USA)

Variations: Prisoners are sometimes allowed to link hands and stand in a human chain in the direction of the nearest territory boundary to make it easier to get rescued.
Each team player puts a 'treasure' down inside their territory for the opposing team to try and steal.

Also known as: French and English; Prisoners; Scotch and English

Card Flicking

This can be played with playing cards although cigarette cards used to be best. Players stand a short distance from a wall and, holding one card at a time horizontally between first and second fingers, they take turns in flicking cards towards the wall. Any card that falls on another card takes that and all cards lying down. So a skilled card flicker can soon gain quite a collection!

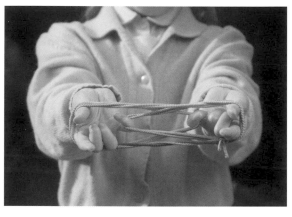

Cat's Cradle

A simple but absorbing game for two players where the only thing required is a length of wool or string. It's rather like doing crochet with your fingers. One person winds the wool round their hands and their partner then removes it by lifting certain strands with their fingers. Each player takes it in turn to lift the cat's cradle off their partner's hands by performing a sequence of moves which result in different, and often very intricate, patterns.

'Sounds really weird now!' (Lynda Treliving, Marden, Kent)

Variations: A length of elastic is wound round the feet of two players, or two chairs. Players jump in and out using their feet to manipulate the elastic into shapes. Difficult to do and very energetic!

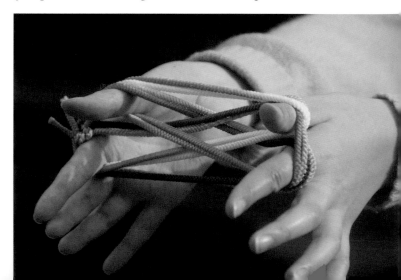

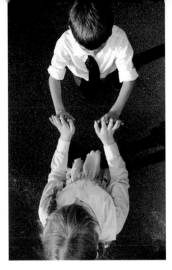

Clapping Games

Enjoyed by children for centuries these simple games are just as popular today. They are often played with a single partner but can be adapted for a group standing in a circle. The game usually consists of performing a sequence of hand movements and singing or speaking a rhyme that often gets faster and faster culminating in a dramatic, and noisy, ending. There are countless different versions and many are altered to suit the mood or interests of the children playing.

Here are some old favourites:

Pat-a-cake, pat-a-cake, baker's man,
Bake me a cake as fast as you can,
Pat it and prick it and mark it with B
And put it in the oven for Baby and me.

My mother said I never should
Play with the gypsies in the wood,
If I did she would say,
'Naughty girl to disobey!'

See, see my playmate,
Come out and play with me
And bring your dollies three;
Climb up my apple tree,
Slide down my rainbow
Into the cellar door,
And we'll be jolly friends
For ever more, more, more,
More, more, MORE!

Bo Bo Skeeotin Dottin,
Na Na Na Na Boom Boom Boom,
Meeny Eeny Otin Dottin,
Bo Bo Skeeotin Dottin,
Bo Bo Skeeotin Dottin,
Boom!

Conkers

Every autumn, as the fruit of the horse chestnut tree bursts from its prickly case, the game of conkers comes into its own. Or it used to. Now sadly banned from many school playgrounds because of health and safety issues, many children today have no idea how to play it! Fortunately, there are conker aficionados throughout the country and there is even a World Conker Championship held every year in Ashton, Northamptonshire.

Like all good games the rules are very simple. Each player has his own conker which has been pierced with a skewer so that a boot lace or length of string can be passed through it. Then a knot is tied at one end. The game is played in pairs; one player holds out his conker at arm's length while his opponent attempts to hit it with his conker. Each player takes a turn to try and destroy the other player's conker and the game ends when one conker finally breaks. The winning conker is given a number for each conker broken, for example if a conker has broken six others it is known as a 'sixer'. If a broken conker already has a number of accredited wins then that number is added to the winning conker, so if one sixer breaks another with three wins, the winning conker is a 'niner'. There are all sorts of ways of hardening up your conkers – soaking in vinegar or baking them in the oven are favourite ploys – but these are not approved of.

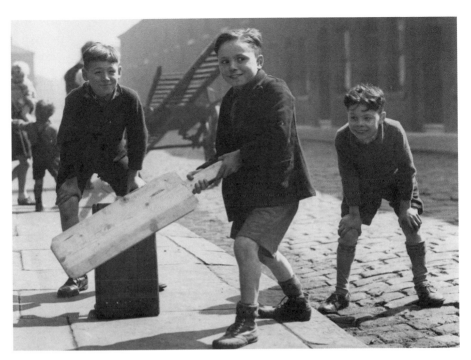

Cricket

A versatile game for any number of players. When streets were quieter, cricket games were played in the road with the wickets chalked up on walls. A tennis ball was used and this was dampened so that it would smudge the chalk if a player was bowled out. It was always best to use a soft ball where there were a number of windows about!

'Wickets were chalked on lavatory walls or the gable ends of houses and boundaries were agreed; the lamp post by the fish and chip shop was the offside boundary, the old church wall the onside boundary. One hand catches were required if the ball bounced off a wall; hit it into Mrs So-and-So's lavatory yard and it was six and out.' (David Thornton, Leeds)

Dead Man Arise!

One member of the group lies on the ground and is covered with a coat, jumper or whatever comes to hand. The rest of the group walk slowly round the 'body' mournfully declaring, 'Dead man arise; dead man arise.' This can go on for some while as the person playing the part of the dead man bides his time before suddenly leaping up and chasing the 'mourners'. Anyone caught becomes the 'dead man'. A great game of suspense!

Also known as: Green Man Arise!

Diabolo

The game originated in China in about the 3rd century BC and its unusual name derives from the ancient Greek words *'dia'* meaning 'through' and *'ballo'* 'to throw'. The diabolo (sometimes misspelt as 'diablo') is shaped rather like an egg-timer with a very narrow centre and it is thrown across a string held between two sticks. The string is about the length of your outstretched arms and the diabolo is made to spin along by raising one of the sticks very quickly and rhythmically. This is not as easy as it sounds and the best way to get started is to first roll the diabolo along the ground and then raise it up on the string when it gets going. Once this technique has been mastered all sorts of tricks are possible – the diabolo can be tossed high in the air and caught; it can be made to leave the string and travel along your arm; jump over parts of the body, like your foot; thrown in a circle or other clever moves like 'Chinese Whipping', 'Around the World' and 'Rip-offs'.

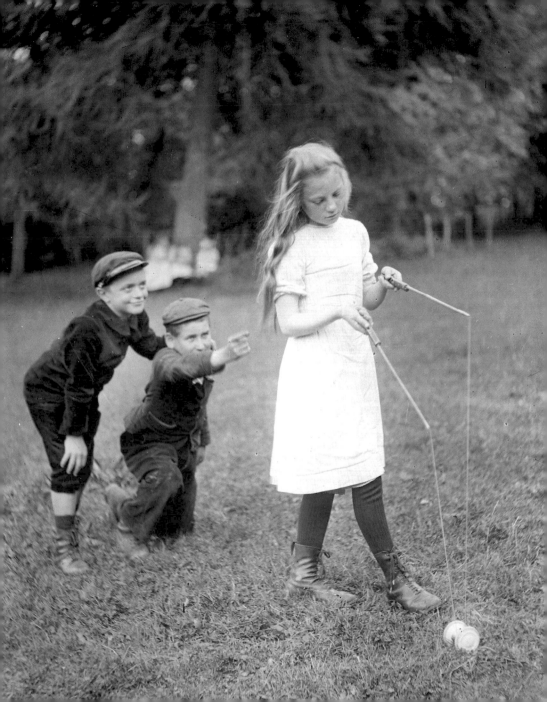

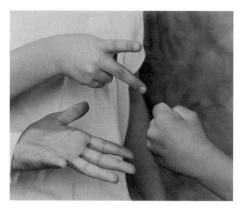

Dips

The majority of group games involve someone being selected to be 'It', 'He', 'On', 'Catcher' etc. Sometimes a simple toss of a coin decides the matter but often a ritual rhyme is used instead. Members of the group line up and one person goes along the line while reciting the rhyme, counting themselves in as well. The person being pointed at on the last word is the one chosen as It (or else they step out and the rhyme begins again until the last one left in becomes It). The rhyme often ends with the additional, *'O-U-T spells out, so out you must go!'* There are an incredible number of these 'dips' and here are few favourites:

Eenie, meanie, meinie mo,
Catch a tiger by his toe,
If he hollers, let him go,
Eenie, meanie, meinie mo!

Two, four, six eight,
Mary's at the cottage gate,
Eating cherries off a plate,
Two, four, six, eight.

One potato, two potato,
Three potato, four,
Five potato, six potato,
Seven potato more.

Tinker, tailor, soldier, sailor,
Rich man, poor man, beggar man, thief.

Yan, tan, tethera, methera, pimp,
Sethera, lethera, hothera, dothera, dick,
Yan-dick, tan-dick, tether-dick.
Mether-dick, bumfit,
Yaner-bumfit, taner-bumfit,
Tethera-bumfit, methera-bumfit,
Gigert.

Ickle ockle black bottle,
Fishes in the sea,
If you want a pretty maid,
Please choose me.

To decide which team goes first, the dip of Ick-ack-ock can be done. Each team captain holds his hand behind his back and at the signal 'Ick-ack-ock' he brings out stone (clenched fist); scissors (forefinger and middle extended) or paper (open palm). Paper beats stone (as it can wrap up the stone); scissors beat paper (as it can cut through it); stone beats scissors (as it blunts them).

Duckstones

Large stones are piled one on top of the other and then each player takes a turn throwing a ball at the pile. The aim is to knock off the top stone without disturbing the rest of the pile.

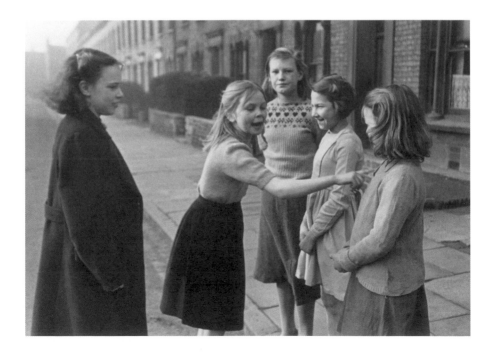

Eggity-Budge

A game popular in Yorkshire in the 1950s, it probably gained its unusual name from the slang 'egg' for person (used in referring to someone as a 'good egg' or a 'bad egg') and budging (moving). It is in many ways similar to another game with eggs in its name – *see* Bad Eggs.

A group choose someone to be 'It'. Someone else in the group throws a tennis ball as far as possible in any direction and the person who is It has to chase the ball while the other players run about. On picking the ball up, It shouts 'Eggity-budge' and everyone else has to stand still. A victim is then selected by the boy who is It and he

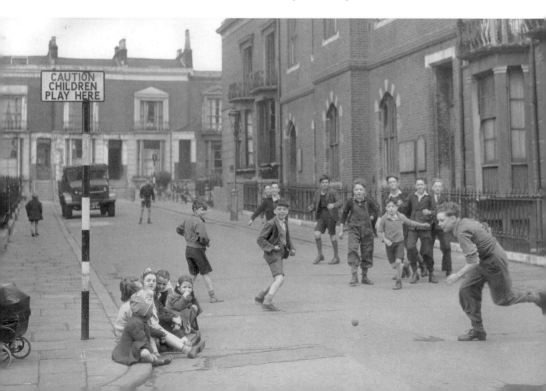

moves towards them by the means of three hops, three steps and the distance of three spits. On reaching the end of this measurement, he has to throw the ball at the victim to try and hit them below the knee. If the ball misses, everyone is allowed to run further away until It retrieves the ball and 'Eggity-budge' is called out again. However, if the ball hits, that person is out of the game and the whole process is repeated. The game ends when everyone is finally out or until the game loses its appeal!

Eller Tree

Another traditional game still played in Yorkshire. A group of children select the tallest to be the 'tree' and the rest of the group join hands and wind around her chanting, 'The old eller tree grows thicker and thicker.' When the last person has joined the huddle, everyone lets go their hands and jumps apart shouting, 'A bunch of rags, a bunch of rags', and they then try to stamp on each others' toes. This curious game has its origins in the ancient custom of 'tree dressing' where a tree would be decorated with pieces of material to ensure good fortune. The 'eller' is the alder, a common native tree.

'I often look back on those days and remember how fit and healthy we all were even into the war years when we had to contend with rationing. I know that we were very lucky in some ways as we did not have to worry about traffic, only the horse-drawn carts of delivery men or bicycles, but I am sure that we were so much happier and fitter than the present-day children who spend so much time glued to computers.' (J Hicks, Somerton, Somerset)

Farmer's in his Den

This is probably the most popular of all the 'ring' games that are played in a circle by a group of children. One person is chosen to be the 'Farmer' and he stands in the centre of the circle while the rest sing:

The Farmer's in his den,
The Farmer's in his den,
E-i, E-i, the Farmer's in his den.

The Farmer wants a wife,
The Farmer wants a wife,
E-i, E-i, the Farmer wants a wife.

The Farmer then chooses a wife from the children around the circle and she goes to join him in the centre. Then other verses are sung and other people selected:

The wife wants a child etc.
The child wants a nurse etc.
The nurse wants a dog etc.

As soon as the dog has been chosen, the last line, 'We all pat the dog', is sung. This is what everyone has been waiting for! All the children then rush to the player who has been chosen as the dog and pat him (often none too gently!) An alternative ending is, 'The dog wants a bone etc' and then the bone is patted.

Variations: Numerous regional variations and word differences.

Also known as: The Farmer in the Dell

Finger Games

Contorting fingers into all sorts of shapes has always been a simple and engrossing form of amusement. Probably the best known game is performed to this rhyme:

Here's the church (interlock fingers of both hands)
And here's the steeple (raise two index fingers)
Open the doors (open two thumbs)
And see all the people (turn hands over and waggle fingers about)
Here is the parson going upstairs (wrap one thumb around the other)
And here he is saying his prayers (move thumb backwards and forwards)
'Dearly beloved brethren,
Is it not a sin
That when we peel potatoes
We throw away the skin?
The skin feeds the pigs,
Then the pigs feed us.
Dearly beloved brethren,
Is it not thus?'

Finger games using paper are also easy and fun. For example, take a square of paper and fold each of the corners over to make another square. Turn over and do the same again. This will give you four small squares on one side. Then write numbers on the outside flaps; colours on the next layer and messages (such as 'You will meet a tall dark stranger' or 'Take care on Friday') on the inside. Now put the index finger and thumb of each hand in the four small square pockets so that you can make the shape of baby bird's beak. Ask someone to choose a number; when they have chosen, make that number of moves forwards and sideways, then ask them to choose from one of the colours revealed. Open the flap and read the message under the inner flap.

Follow my Leader

One person is selected to be the 'leader' and everyone else has to follow her. Anyone failing to copy her exactly is out of the game.

Football

Budding David Beckhams and Wayne Rooneys of today still take to the streets and fields for impromptu games of football just as their grandads used to do. Fifty years ago the streets were quieter and it was easier to enjoy a game without interruptions, using coats as goalposts and an old ball. In the austere period after the Second World War it was difficult to get a proper leather football and children used to kick anything they could get their hands (or feet!) on. Usually the person providing a suitable ball was allowed to be a team captain as a reward. Rules (and the numbers in a team) were flexible!

'Any sized ball was used but the bigger the better. Whoever provided it became captain of one of the teams. Old Arthur Tate reminisced over 60 years later how he had never achieved that distinction. He had never had a ball good enough to be played with until one Christmas. Then he was given a large rubber ball which was ideal. Triumphantly he took it to show his pals but what a disappointment was in store. Another boy in the gang had been given a brand new proper leather football. Of course the boys opted to play with that and Arthur's ball became no more than the goalpost.' (David Thornton, Leeds)

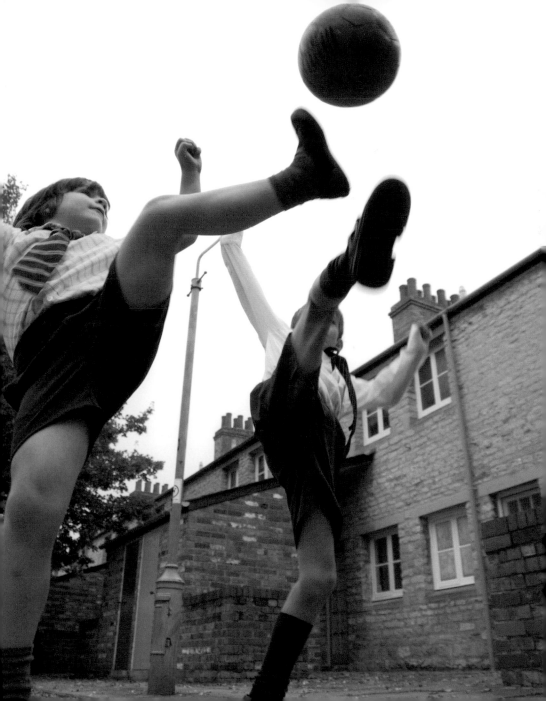

French Cricket

This game is not French and its only similarity to cricket is that it is played with a bat. Any number of people can play. A circular boundary is marked out and the batsman stands in the centre while everyone else fields. One fielder becomes the bowler and he throws a tennis ball underarm at the batsman trying to hit him below the knee. The batsman protects his legs with the bat whilst also trying to hit the ball. If the bowler succeeds in hitting the batsman's legs, the batsman is out and the bowler becomes

the batsman. If the batsman hits the ball and is caught, then the fielder catching him becomes the batsman. However, if the ball is hit and no one catches it, the batsman scores 'runs' by making a full circle of his body with the bat, passing it from hand to hand. When a fielder picks up the ball, he becomes the bowler and has to throw the ball at the batsman from the position he is in. (In the case of 'no balls' the ball is returned to the bowler who threw the ball). The batsman cannot move his feet and has to twist his body round to protect his legs from the new angle. If he moves his feet (or falls over!) he is out. The player with the highest number of runs wins.

Grandmother's Footsteps

An old favourite that can be played with any number of players. One person is selected to be 'Grandmother' and she stands some distance from the rest of the players with her back to them. The others all stand behind a baseline and then, at an agreed moment, begin to creep up on Grandmother attempting to be the first to touch her shoulder. However, every time Grandmother turns round the players have to freeze – anyone she sees making even the slightest move has to return to the baseline. Some players adopt the 'tortoise' approach – moving inch by inch with their eyes riveted to Grandmother's back to detect the first indication she is about to turn. Others prefer the riskier 'hare' technique of sprinting as fast as possible towards her, trusting that they'll be able to screech to a halt in time. The first person to touch Grandmother's shoulder wins the coveted role of Grandmother in the next game.

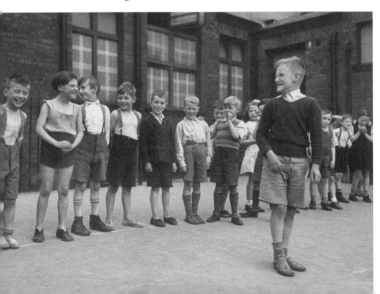

Also known as: Black Pudding; Creepy Jinny; Peep Behind the Curtain; Sly Fox; Victoria

Here We Go Round the Mulberry Bush

Although Wakefield in Yorkshire claims this game originated from prisoners walking round a mulberry bush in the exercise yard of the city's gaol, it is likely to have far earlier origins and may date to the medieval period. The game is sung to the same tune as 'Nuts in May' (*see* pages 60–1).

A group of players join hands to form a circle and walk, skip or dance around, stopping to mime the various tasks mentioned in the song. The chorus is repeated after each of the verses. The game is an educational one, originally providing valuable lessons on cleanliness and home management – and there are all sorts of variations on the tasks mentioned. The beauty of the game is that the song can be adapted as the players see fit, and works just as well if the tasks include such things as 'This is the way we play our Gameboy' or 'This is the way we eat our crisps'!

Chorus:
Here we go round the mulberry bush,
The mulberry bush, the mulberry bush,
Here we go round the mulberry bush
On a cold and frosty morning.

This is the way we wash our hands,
Wash our hands, wash our hands,
This is the way we wash our hands
On a cold and frosty morning.

This is the way we mend our clothes,
Mend our clothes, mend our clothes,
This is the way we mend our clothes
On a cold and frosty morning.

This is the way we wash our clothes,
Wash our clothes, wash our clothes,
This is the way we wash our clothes
On a cold and frosty morning.

This is the way we iron our clothes,
Iron our clothes, iron our clothes,
This is the way we iron our clothes
On a cold and frosty morning.

This is the way we scrub the floors,
Scrub the floors, scrub the floors,
This is the way we scrub the floors
On a cold and frosty morning.

This is the way we sweep the house,
Sweep the house, sweep the house,
This is the way we sweep the house
On a cold and frosty morning.

This is the way we bake our bread,
Bake our bread, bake our bread,
This is the way we bake our bread
On a cold and frosty morning.

This is the way we go to church,
Go to church, go to church,
This is the way we go to church
On a cold and frosty morning.

Another very popular version of the song includes these verses:

This is the way we go to school,
Go to school, go to school,
This is the way we go to school
On a cold and frosty morning.

This is the way we come from school,
Come from school, come from school,
This is the way we come from school
On a cold and frosty morning.

This is the way the soldier goes,
The soldier goes, the soldier goes,
This is the way the soldier goes
On a cold and frosty morning.

This is the way the sailor goes,
The sailor goes, the sailor goes,
This is the way the sailor goes
On a cold and frosty morning.

This is the way the beggar goes,
The beggar goes, the beggar goes,
This is the way the beggar goes
On a cold and frosty morning.

This is the way the lady goes,
The lady goes, the lady goes,
This is the way the lady goes
On a cold and frosty morning.

The actions to these verses are a slow walk for the going to school and a fast skip back, marching for a soldier, dancing a hornpipe for a sailor, putting hands out for the beggar and lifting imaginary long dresses for the lady.

'Depending on the weather and the time of year, various games came and went throughout the school terms. Why and how they were started is still a mystery but suddenly the whole female population of the primary school would be involved. I don't remember any boys joining in but they were playing football and considered it sissy to play with the girls.'
(Lynda Treliving, Marden, Kent)

Hide and Seek

Ideal for playing inside or out. One of the group is chosen as 'It'; she then hides her eyes and counts to an agreed number (often 100) while the rest run off and hide. Boundaries are usually agreed first so that the seeker has some idea of where to look, and a place is selected to be 'home' or 'base'. When It has finished counting, she shouts 'Coming' and sets off on her quest. Anyone she finds and touches on the shoulder is then out of the game, but if a player manages to get back to base undetected they are 'safe'.

Variations: The first person to be found becomes It while the last is the winner.
Sardines: One person goes off to hide; the rest of the players count to 100 and then try to find them. Anyone discovering the hiding place, joins the person hiding and the game continues until only one person is left seeking while the rest are all crammed into one hiding place.

Also known as: Hiding Seek; Cat's Eyes or Ghosts (when played after dark)

'I always hoped that Michael Fairchild would play Sardines so that we could share a hiding place together – but he never did!'
(Audrey Ball, Cheltenham, Gloucestershire)

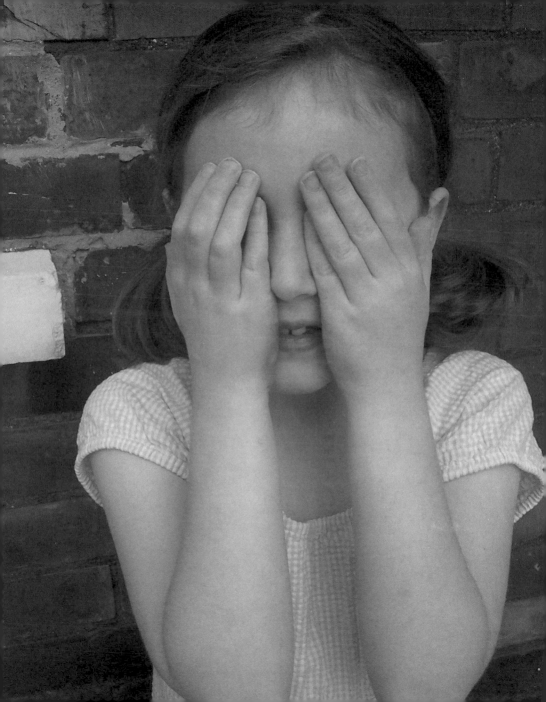

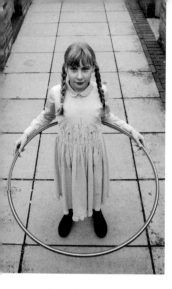

Hoops

All sorts of games can be played with a simple hoop – it's not just for bowling along the ground. The Victorians were particularly fond of playing with hoops and often mass 'hoop parties' assembled in parks to enjoy the sport. They also enjoyed a game called 'Turnpikes' which involved steering hoops through a series of gates (pairs of bricks or stones some 6in apart). Hoops were made of wood or iron (even a bicycle rim would do!) but now most are made of plastic. The brightly coloured 'hula' hoops enjoyed a great craze in the 1960s with girls across the land twisting and twirling at every opportunity.

'There were iron hoops, with the guider attached, for boys. Girls had wooden hoops almost twice as tall. Frequently these warped and were therefore not perfectly circular, but this only added to the fun.' (Cyril Francis Campbell, Liverpool)

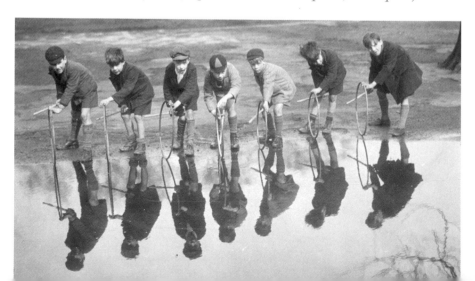

Hopscotch

A grid of boxes is drawn out on the playground or pavement using a piece of chalk. These are then numbered one to ten. A flat object such as a stone, coin or tin lid is then thrown into box number one on the grid and the first player has to hop and jump all the way through to the top box and back again,

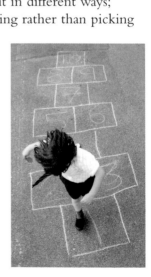

picking up the object on the way back. They then throw it into each of the squares in turn, hopping to retrieve it. However, if any lines are stepped on their turn is over and another player has a go.

Variations: Many, with varying numbers of boxes laid out in different ways; sometimes kicking rather than picking up the object.

Also known as: Bays

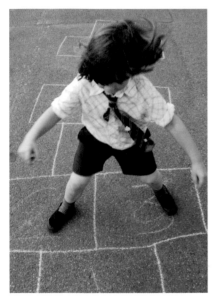

'The player threw a "hitchie dobber"
(small stone/token) in the first bay and then
hopped on one leg up to ten and picked up
the hitchie dobber on the return run.'
(Bob Buyers, Newcastle upon Tyne)

45

I Sent a Letter to my Love

This game needs to be played by a large group of at least ten people. One person is chosen and given a handkerchief while the rest stand in a circle. The player with the handkerchief runs around the outside of the circle singing or chanting:

I sent a letter to my love
And on the way I dropped it,
One of you has picked it up
And put it in your pocket.

She drops the handkerchief behind one of the players who then has to pick it up and race around the circle the other way. The first person back to the empty space is the winner and the loser has to drop the handkerchief.

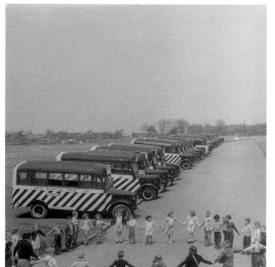

Variations: Bump on the Back: instead of dropping a handkerchief, a player is selected by being tapped on the back.
Dummy: the loser of the race for the empty space has to go to the centre of the circle and suck her thumb.

Also known as: Drop Handkerchief

In and Out the Dusty Bluebells

A ring game which tends to get more and more boisterous the longer it goes on! It needs a good number of players who stand in a circle and hold hands, lifting their arms up to form arches. One person is chosen to start the game off and they run round the circle weaving in and out of the arches while everyone sings:

In and out the dusty bluebells,
In and out the dusty bluebells,
In and out the dusty bluebells,
Who shall be leader?

At the end of this verse, the chosen person stops and taps whoever is nearest them in the circle while the song continues:

Tip, tap on your shoulder,
Tip, tap on your shoulder,
Tip, tap on your shoulder,
You are the leader.

That player then comes out of the circle, is grasped round the waist by the player who has tapped them on the shoulder and the two weave in and out of the arches while the song is repeated. Eventually there is a long crocodile of children desperately hanging on to each other.

Also known as: In and Out the Dusky Bluebells; In and Out the Rocking Bluebells

Jacks

There was a great craze for this game in the 1960s when children would come into school with a little cloth bag round their wrists. The bag contained their 'jacks' and a small rubber ball ready for playtime.

Jacks are metal, 'sputnik'-shaped objects (usually 10–12 in number) and these are thrown gently onto the ground so that they scatter on landing. If playing with one set, the first player throws a small rubber ball up in the air and, at the same time, scoops up one of the jacks before catching the ball. They then throw the jacks again and have to pick up two jacks when they throw the ball, then three, and so on until all have to be picked up on one bounce of the ball. If any are missed or dropped the next player has a turn. If the players have their own sets then the game can be played simultaneously.

'What could be nicer than sitting in the sunshine in the summer playing jacks throughout a long lunch break?'
(Lynda Treliving, Marden, Kent)

Variations: There are many variations about the way the jacks are picked up etc. It is also a game that can be played with any number of players or even on your own.

Also known as: Five Stones: an earlier form of the game using just five smooth stones or pieces of wood.

'I developed callouses on the bottom of my right hand little finger because I played so much.'
(Lindy McKinnel, Lymm, Cheshire)

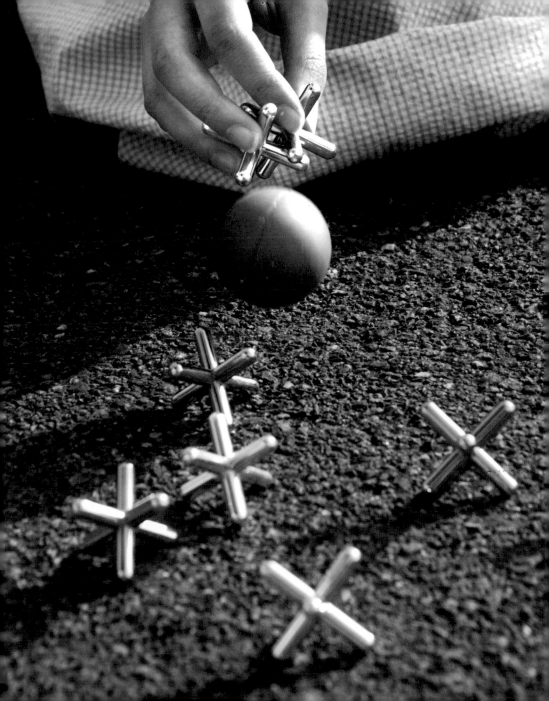

Kerb

This game can be played with two people or in two teams. The players position themselves facing each other on opposite sides of a pavement. A football is thrown by one team at the opposite kerb. If it hits the kerb and bounces back the team get one point; if it hits the lip of the kerb and bounces back and is then caught, the team get two points. The winners are the first to score 20 points (or whatever has been the target agreed before the game).

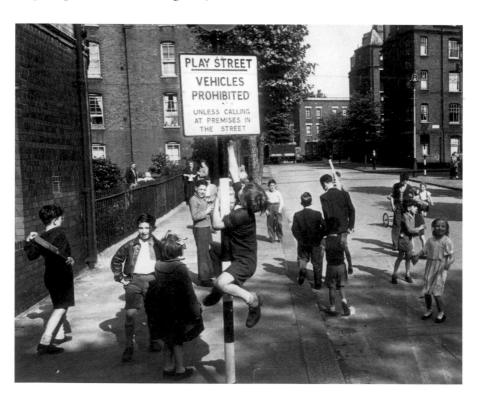

Kerb or Wall

A popular and energetic street game. One person is selected to be 'It' and the rest of the group line up against a wall with their hands outstretched. The player who is It then slaps everyone's hands in turn while reciting a rhyme such as:

Two little dicky birds sitting on a wall,
One named Peter, one named Paul,
Paul said to Peter, Peter said to Paul:
'Let's have a game of Kerb or Wall.'

The last person to have his hands hit chooses either Kerb or Wall. If he selects the first, he has to run to the nearest kerb, back to the wall he started from, then to the wall on the opposite side of the street and then back again. Meanwhile his opponent has to do the opposite of what has been chosen, that is Wall, which involves running to the far wall, back to the wall he started from, then to the nearest kerb and back again. The winner of this race becomes It and can choose an opponent to compete against in the next game.

Kernockers

This game went through a short-lived craze in the 1960s. Two small balls attached to a length of string are held in the middle, and then knocked together by bouncing them up and over your wrists in a variety of different moves.

'Plenty of bruises with that game.'
(Sandra Taylor, Worcester)

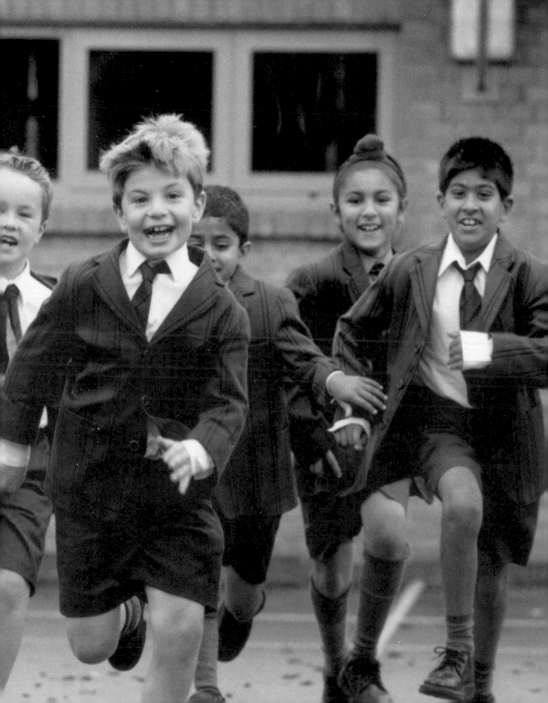

King

This game has long been played in all regions of the country. It requires a group of about 10–20 players who form a circle standing with their legs apart. A tennis ball is dropped in the middle of the circle and, when it runs through someone's legs, that person becomes 'King'. The King takes up the ball and bounces it ten times while everyone else runs away within an agreed boundary. The King gives chase trying to hit the other players on the body or legs with the ball. He is not allowed to run with the ball in his hands but he can bounce the ball along. The game usually gets fast and furious with players ducking and diving to avoid the ball – they are also permitted to use their clenched fist to fend off the ball. Once a player has been hit, he joins the King's side and the ball can be passed between them during the pursuit. However, once the King has been joined by others, anyone with the ball has to stand still. The last person left unhit is the winner and becomes King.

Variations: Sometimes the King is chosen in another way.

Also known as: Hot Rice; Kingy

Knocking Down Ginger

A game of mischief that used to really irritate adults but which children found hilarious. It was a daredevil game of who could knock on as many doors as possible and run off before being caught by an irate homeowner!

Also known as: Cherry Picking

Leapfrog

A game that can be played with any number of people – but the more the merrier. One person bends over and grasps her ankles or knees – making sure that her head is well tucked in! The next player vaults over her, runs a few steps and then bends over to form a 'back'. The next player then has two jumps to make before also bending down to make a third back. This goes on until there are no more players to come, and then the first in the line stands up and leapfrogs over the second and so on until everyone gets fed up or falls over. The game gets more difficult when the backs are high and even harder if players dip their backs when being vaulted over!

Variations: Usually the line is presented sideways on but it is also often played with bottoms first.
It can also be played in a circle.

Letters

One person from a group of players is chosen to be 'It' while the rest stand in a line some distance away. The girl who is It then shouts out a letter and anyone who has that letter in their name is allowed to advance one step for every letter. The first person to touch It is allowed to call out the letters in the next game.

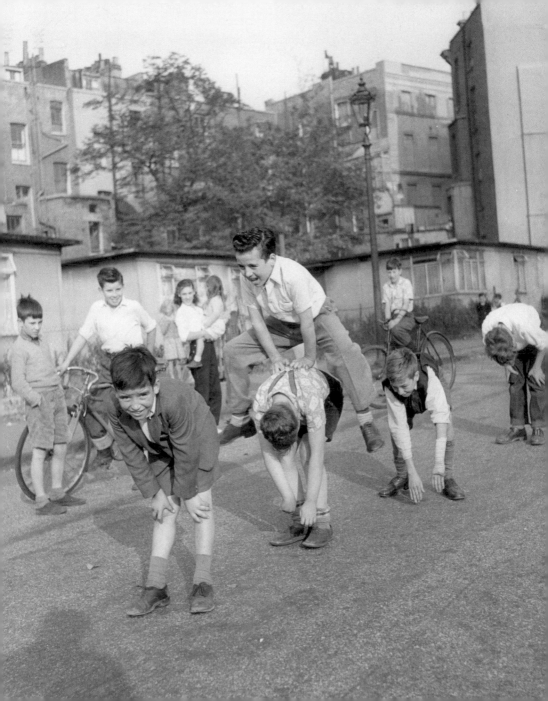

Marbles

Played by the ancient Egyptians and the Romans, the game is thousands of years old. The earliest marbles were literally marble balls, but cheaper ones of baked clay, and later glass, were soon being used.

Marbles are lovely objects in themselves. Many are made of glass, encapsulating swirling colours with the vibrancy of a stained glass window, while others are fashioned from delicately veined stone or glittering metal. The beautiful look and smooth feel of them, the satisfying chink as they knock against each other, all ensure that the game of marbles will continue to remain a great favourite among young and old alike.

'One game really stands out – marbles played with metal bottle tops. I suppose this developed because it was so difficult getting real marbles during the war – this would be pre-1944 – and the only ones you could buy were crude clay ones. . . My brother and I cheated a bit I suppose. Our gran worked in a pub part-time and would occasionally bring home a carrier bag full of bottle tops which gave us an unfair advantage. . . I also remember that I swapped a lead cowboy (rifle at the ready behind a lying-down horse) for a big glass "alley" about 1½ inches in diameter with a coloured spiral inside it, but my mum made me get it back!'
(Mike George, Norwich)

Marbles (often known as 'taws') have many intriguing varieties – including aggies, alleys, commoneys, immies, potties, stoneys, tolleys – and come in all sorts of sizes from tiny to monster marbles. Dedicated players spend much time practising their marble-throwing

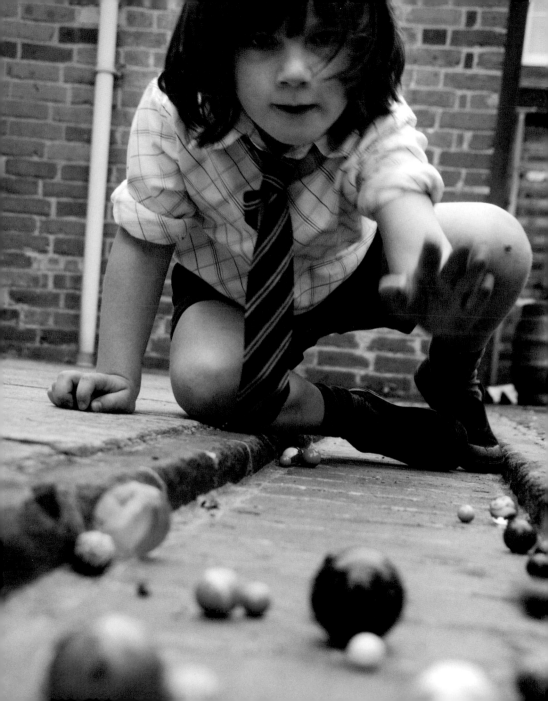

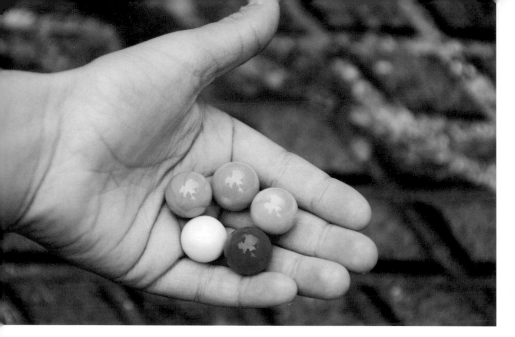

skills and there is a whole vocabulary of techniques such as knuckling down, histing and plunking! There is even a national championship for the game, which has been held annually at the Greyhound pub in Tinsley Green, West Sussex, since 1932.

There are hundreds of different ways of playing with marbles but most fall into three categories. First there are the circle games where a ring is marked out as the playing area. Each player takes turns rolling one of their marbles, taking any of their opponents' marbles they manage to knock out of the circle.

In contrast, chase games are played in a straight line. One player rolls out a marble and then the next player attempts to hit it. If he does, he can take his opponent's marble for his collection; if he misses, then the first player has another shot, and so on. Before streets became so busy, this game was often played in the road gutter as it was easier to keep the marbles travelling in a straight line.

'The balls from machine bearings called "steelies" were especially prized for their ability to overwhelm glass marbles to the cry of "Not Fair!" and "Cheater!" from the loser.'
(Bob Buyers, Newcastle upon Tyne)

Another way of playing is the hole game where the marbles have to be rolled into three holes about 10ft apart in turn, and then back to the start. This game needs considerable skill and cunning tactics as it is permissible to knock out your opponents' marbles by striking them hard with your own. Suitable small holes used to be scraped out of the road or pavement – a practice less easy to do today!

As the prize for all the games is taking the marbles of opponents, players rarely risk playing their precious favourites.

May I?

One player is chosen to be the 'Catcher' or 'It' and she stands some distance away from the others and facing them. The Catcher selects one player from the group and tells them to take a number of bunny-hops, cartwheels or whatever towards her. The selected person has to obey but has to politely ask, 'May I?' before proceeding. If this is forgotten in the excitement, they have to return to the start line. The winner of the game is the first person to reach the Catcher.

Variations: Members of the group can make a request such as, 'May I take five steps forward?'

Also known as: Mother, May I?

Nuts in May

Another game (*see* page 40) that involves a cold and frosty morning – must be something to do with keeping warm in the British weather! Gathering nuts in May seems unlikely as nuts aren't usually around until autumn, so this game probably refers to 'knots' of spring blossom gathered for traditional May morning celebrations.

Players divide into two teams and form up in two lines facing each other. The first team skips towards the second singing:

Here we go gathering nuts in May,
Nuts in May, nuts in May,
Here we go gathering nuts in May
On a cold and frosty morning.

They skip back to their original position and the second team then skip towards the first singing:

Who will you have for nuts in May,
Nuts in May, nuts in May,
Who will you have for nuts in May
On a cold and frosty morning?

They too return to their original position and the first group advance again, choosing a player from the second group:

We will have Sarah Jane for nuts in May,
Nuts in May, nuts in May,
We will have Sarah Jane for nuts in May
On a cold and frosty morning.

The second team then ask:

> *Who will you have to*
> * pull her away?*
> *Pull her away, pull her away?*
> *Who will you have to pull*
> * her away*
> *On a cold and frosty morning?*

The first team make their selection from their own group – usually someone a lot larger and stronger – and sing:

> *We will have Mary Ellen*
> * to pull her away,*
> *Pull her away, pull her away,*
> *We will have Mary Ellen to*
> * pull her away*
> *On a cold and frosty morning.*

The people selected then come to the area between the two teams and have a tug of war. The loser joins the winning side and the game continues until one team loses all its players.

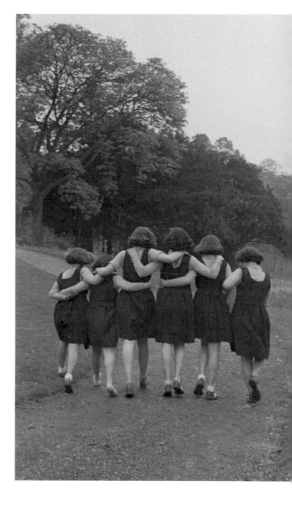

'The playground was divided by a wide, white line, the distinction between boys and girls. What happened on the boys' side was, and still remains, a mystery!' (Mary Folley, Leigh-on-Sea, Essex)

Oats and Beans

A favourite with boys and girls alike – although boys are not so keen on the last line of the verse! The players all hold hands and form a circle. One person is chosen to be the 'Farmer' and he stands in the centre of the ring while the rest walk around singing:

Oats and beans and barley grow,
Oats and beans and barley grow,
You nor I nor anyone know
How oats and beans and barley grow.

Then everyone stands still to sing the next few lines while the Farmer mimes the actions of the words:

First the Farmer sows his seed,
Then he stands and takes his ease,
Then he stamps and claps his hands,
And turns him round to view the lands,
Waiting for a partner, waiting for a partner,
Open the ring and take one in.

The Farmer chooses a partner who joins him in the centre while everyone else joins hands again and dance round the couple singing:

Now you're married you must obey,
You must be true to all you say,
You must be kind, you must be good,
And help your wife to chop the wood.
Chop it thin and carry it in
And kiss your partner in the ring.

Oranges and Lemons

A very old game that dates back to at least the late 17th century – and probably long before that. Two children are chosen to form an arch and they secretly decide between them who is to be Orange and who Lemon. They then clasp hands and hold up their arms while the rest of the players go under the arch singing, or shouting, this song:

> 'Oranges and lemons', say the bells of St Clement's,
> 'I owe you five farthings', say the bells of St Martin's,
> 'When will you pay me?', say the bells of Old Bailey,
> 'When I grow rich', say the bells of Shoreditch,
> 'When will that be?', say the bells of Stepney,
> 'I do not know', says the great bell of Bow.
> Here comes a candle to light you to bed,
> Here comes a chopper to chop off your head,
> Chip, chop, the last man's head (or you're dead)!

The last few lines are accompanied by much lowering and raising of the arch arms to create a delicious sense of anticipation before the arms are brought crashing down to capture the person passing under the arch on the last word. The captured child then has to decide whether they are an Orange or a Lemon and they whisper their choice to the children forming the arch so the rest of the players can't hear. They are told which player to stand behind and the game continues. When all children have been captured and chosen there is a tug of war.

'You could feel your heart beating faster as you got nearer to the arch and I'd try to dash through as quickly as I could so that I wasn't guillotined by those arms!' (Claire Walker, York)

It is claimed that the song records the notes of the church bells in and around the City of London (ie St Clement Eastcheap [or St Clement Dane]; St Martin Orgar; St Sepulchre-without-Newgate; St Leonard's, Shoreditch; St Dunstan's, Stepney and St Mary-le-Bow). The last few lines are a later, probably 18th-century, addition with rather gruesome origins. This was a time when public executions were a real spectator sport and thousands used to cram the streets when the bells of Old Bailey (actually the tenor bell of St Sepulchre) rang to announce an imminent execution. The lighted candle may refer to the Bellman of St Sepulchre who reputedly visited the condemned prisoner at midnight on the Sunday night prior to the execution date to advise them of their fate. Another alternative explanation is that these lines refer to the beheading of Charles I in 1649.

Variations: London Bridge is Falling Down is played in a similar way.

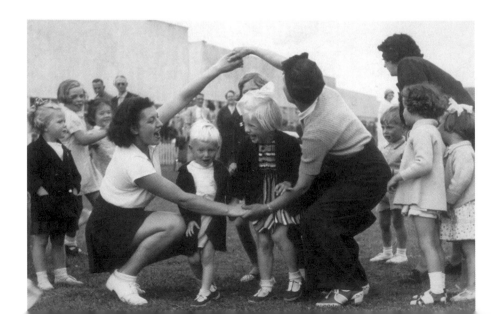

Peanut Rolling

This bizarre game leads to a lot of red noses! Players use the tip of their noses to roll peanuts along a set course which is usually marked along the pavement with chalk. Not surprisingly, it is a game that soon loses its appeal.

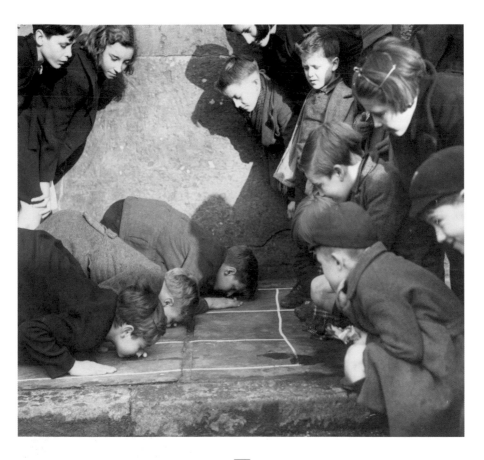

Pick Up Sticks

All you need to play this game is a bunch of thin wooden sticks. Most are sharpened to a point at one end but a couple are sharpened at both ends. They also have different colours painted on them to indicate what score they are worth.

The bunch is held above the ground and dropped so that the sticks fall in a heap. Each player then takes a turn to try and extract a stick without moving any of the others, while the rest of the players keep an eagle eye on the pile ready to shout out if they see even the slightest shift. As soon as a movement is spotted another player has a turn.

Each stick safely removed by a player adds to their score and the winner is the person with the highest total. However, sticks with double points have no score but are particularly prized as they are the only sticks that can be used to flick others off the pile. This absorbing game has been popular for centuries and certainly helps you learn to keep a steady hand and a cool head!

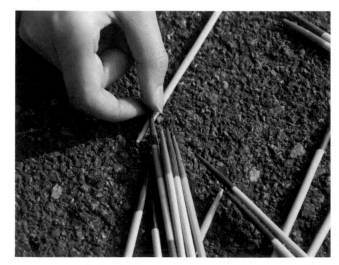

Also known as: Spillicans; Sticks

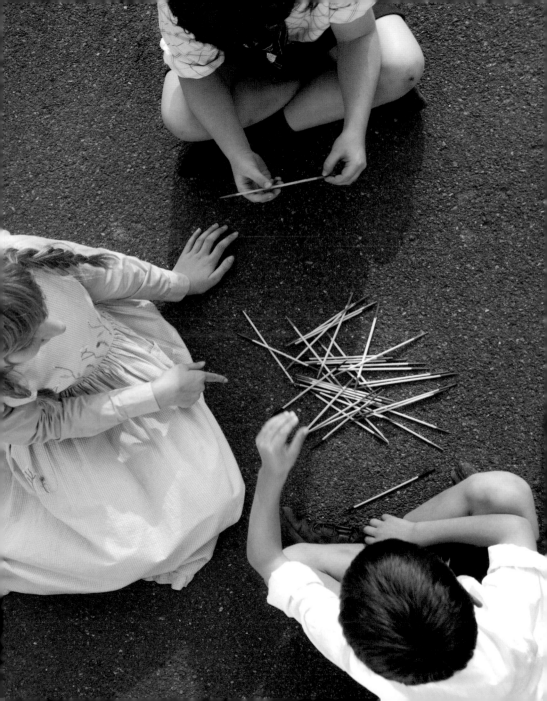

Piggy in the Middle

A game for three players. Two people throw a tennis ball to each other while the third person stands between them leaping up to try and intercept the ball. If they are successful, they come out of the middle and the person who threw the ball becomes the 'piggy'.

Please Mr Crocodile

A strip of ground is marked out as the 'river' and one of the players is selected to be the 'Crocodile'. The rest stand one side of the river and call out, 'Please Mr Crocodile, may we cross your golden river?' The Crocodile chooses a colour and tells them they can cross safely if they are wearing that particular colour. Any player having the selected colour is able to stroll nonchalantly across, the others have to race over trying to avoid the clutches of the Crocodile. Anyone caught has to stay out of the game. Sneaky Crocodiles used to select colours that were unusual and not part of the school uniform.

> *'I well remember stuffing a few coloured hankies in my knickers (a vast navy-blue garment) one day in an effort to cross the river in safety but when it came to it I didn't have the courage to admit it.'*
> (Mary Folley, Leigh-on-Sea, Essex)

Also known as: Boatman, Boatman; Farmer, Farmer, May We Cross your Golden River?; May I Cross the River?

Poor Sally

All the players hold hands and form a circle while the person chosen to be Sally sits on the ground in the middle. She pretends to cry while the other players walk slowly round her singing:

Here sits poor Sally on the sand,
Crying and weeping for her young man.
Get up, Sally, and wipe your tears,
And tell me who you love so dear.

Sally gets up and spends a while carefully selecting a partner from the circle of players. She leads her chosen sweetheart back to the centre of the ring where they dance together while others clap and sing:

Bogey in and bogey out,
And bogey round the garden,
I wouldn't part with my sweetheart
For fourpence ha-penny farthing.

Then another Sally is chosen and so the game goes on.

Variations: There are many variations to this game including Poor Mary and Poor Jenny which begin:

Poor Jenny is a-weeping,
A-weeping, a-weeping,
Poor Jenny is a-weeping,
On a bright summer's day.

Why are you weeping,
Weeping, weeping,
Why are you weeping
On a bright summer's day?

Queenie

One girl is selected to be 'Queenie' and given a tennis ball. She turns her back on the rest of the players. Without looking behind her, Queenie throws the ball over her head. If the ball is caught without bouncing, that girl becomes 'Queenie', but this is a rare occurrence as Queenie usually hurls the ball over her shoulder with great force – and anyway the game is far more fun when the ball bounces. Then there is a mad scramble to get it and the girl who retrieves it immediately hides the ball behind her back and stands still. The rest of the players also put their hands behind their backs and line up with her. Then they all ask:

Queenie, Queenie,
Who has the ball?
I haven't got it,
It isn't in my pocket,
So Queenie, Queenie,
Who has the ball?

Queenie has to turn around and guess which of the players is concealing the ball. If she guesses incorrectly, the person who has deceived her successfully becomes Queenie in the next game.

Also known as: Queen Anne and her Maids

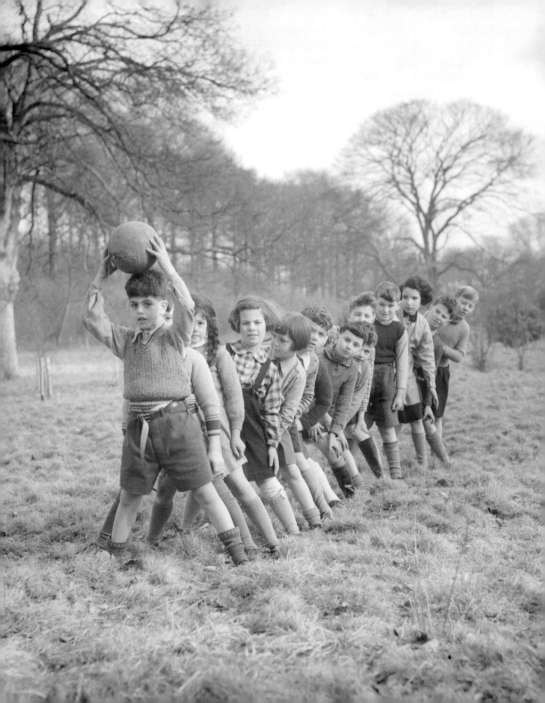

Rallio

An exciting game played with two teams. Two leaders are selected and they choose who they want on their side as well as a place to be the 'base' or 'den'. One team runs away and hides within an agreed boundary area while the other team appoints one person to guard base while the rest search for the rival team. When they find someone, they have to lift them off the ground while shouting, 'One, two, three, rallio!' before marching them back to base to be kept prisoner. However, if the person manages to break free from his captor before the chant is complete he is free to run off and hide somewhere else.

Prisoners are guarded by the base-keeper who has to keep his feet out of the base boundary line. He has to keep a constant vigil for members of the opposing team who try to release the prisoners by running into the base and shouting 'Rallio'. This is dangerous, however, as the base-keeper is able to make anyone a prisoner by just touching their shoulder. The game continues until everyone is caught.

Variations: Numerous variations to the rules of capture and escape.

Also known as: Releaso; Relievo

'I still remember my disappointment when the base post for many of our games, a brick post at the entrance to a group of pensioners' houses, was removed in more recent times and long after I had outgrown such simple childish pastimes.' (Mr K Banyard, Rushden, Northamptonshire)

Ring a Ring o' Roses

Probably the most famous of all ring games. Children hold hands and form a circle, walking or skipping round whilst singing:

Ring a ring o' roses,
A pocketful of posies,
A-tishoo, a-tishoo,
We all fall down.

On the word 'down' everyone sits down as quickly as possible.

It is often claimed that this game dates back to the Great Plague of London of 1664–6. The ring of red roses is said to refer to either the ring of red spots symptomatic of bubonic plague or to the bunch of herbs that people carried around to ward off infection. Sufferers of the plague also sneezed a great deal and invariably died – the 'fall down' at the end of the rhyme. This theory has been discredited but remains a popular explanation.

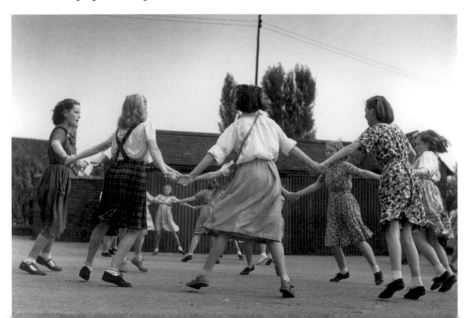

River and Road

A chalk line is drawn to differentiate the 'River' from the 'Road'. One person is chosen to be the leader and she gives orders yelling out either 'River' or 'Road' as she sees fit. This is done as fast or slowly as she chooses and the aim is to cause confusion among the players who have to jump across the line obeying orders. Anyone jumping into the wrong place is eliminated.

Rounders

Although rounders was often played at school using the proper equipment, variations of the game have long been enjoyed by children in their free time. All you need is a thick bit of stick to act as a bat, a ball (preferably soft!) and some jumpers, coats, tin cans (or something similar) to mark out a circle of 'bases'. Two teams are chosen and a coin tossed to decide which side is to bat and which field. Players take turns standing in the batting area to face the bowler and try and hit the ball as far as possible. If they hit the ball a great distance, they run all round the circle of bases and score a rounder. If they miss, or only hit the ball a short distance, they run to the nearest base. The next player in the team then faces the bowler and both players run round the bases according to how well the ball has been hit. Players can be caught or run out, and the winners are the side with the greatest score.

Sheep, Sheep Come Home

Two players from a group are selected to be the 'Shepherd' and the 'Wolf'. The Shepherd takes up a position on one side of the playground, the Wolf stands in the middle and the rest of the players (the Sheep) line up on the far side. The Shepherd then calls, 'Sheep, sheep come home.' The Sheep answer, 'We're afraid of the Wolf!' However, the Shepherd reassures them with:

> The Wolf has gone to Lancashire
> And won't be back for half a year.
> Sheep, sheep come home.

The Sheep then all dash across to the Shepherd while the Wolf tries to catch them by touching them on the shoulder. Those caught either stand out of the game or become Wolves. The winner is the last Sheep left.

Variations: The wolf goes to Devonshire.

Simon Says

A popular party game best played with a large group. One person is chosen to be Simon and they issue orders to the rest of the group who have to obey his commands. For example, Simon might say, 'Simon says, touch your head' and anyone who doesn't is out of the game. But if Simon fails to preface his command with the words, 'Simon says', then the rest of the players don't do as they are told. The object of the game is for Simon to get all the players out, and the last person becomes Simon in the next game.

Skipping

Just a simple rope – but so many games and ways of having fun with it! A traditional skipping rope has shaped wooden handles to make it easier to turn and the rope can be of varying length to suit one skipper or many. Girls in particular seem to love skipping and here are just a few of the many songs, rhymes and games to enjoy.

Single skipping is often accompanied by reciting a rhyme such as this old favourite:

Nebuchadnezzar King of the Jews
Bought his wife a pair of shoes,
When the shoes began to wear,
Nebuchadnezzar began to swear,
When the swearing began to stop,
Nebuchadnezzar bought a shop,
When the shop began to sell,
Nebuchadnezzar bought a bell,
When the bell began to ring,
Nebuchadnezzar began to sing,
When the singing began to stop
Nebuchadnezzar fell down plop.

'I remember the energy required for some of the
games, especially the skipping routines, and I think
that a lot of the games kept us fit as well as warm
in the playground in the winter.'
(Lynda Treliving, Marden, Kent)

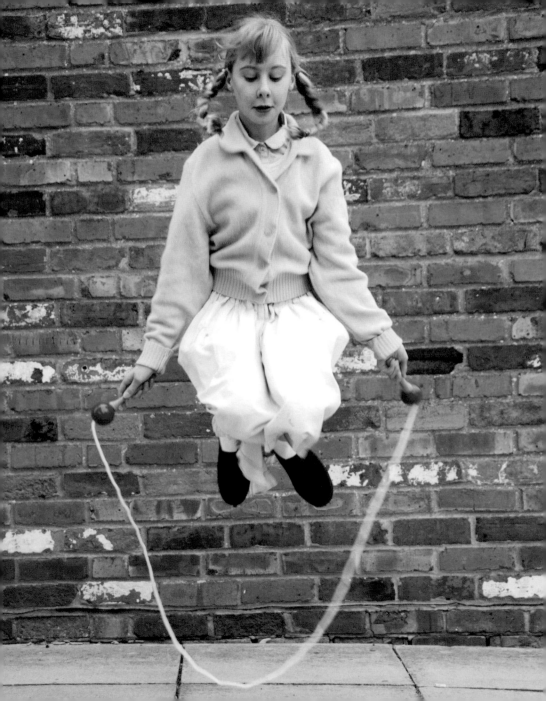

When skipping with three players, two girls are chosen to turn the rope – the 'first ender' and the 'second ender' – while the third skips. When the skipper eventually gets caught up in the rope, she comes out and becomes the 'second ender' while the 'first ender' gets the chance to skip, and the 'second ender' becomes the 'first ender'. Often the skipping is made more difficult by having to do the actions mentioned in a rhyme.

Teddy bear, teddy bear, turn around,
Teddy bear, teddy bear, touch the ground,
Teddy bear, teddy bear, show your shoe,
Teddy bear, teddy bear, that will do!
Teddy bear, teddy bear, go upstairs,
Teddy bear, teddy bear, say your prayers,
Teddy bear, teddy bear, turn off the light,
Teddy bear, teddy bear, say 'Goodnight'.

Other action rhymes include:

I am a Girl Guide dressed in blue,
These are the actions I can do,
Stand at ease,
Bend your knees,
Salute to the officer,
Bow to the Queen,
Turn your back on the leader of the pack
And run right through.

'We used to sing a rude version which ended "Bow to the Queen, Show your knickers to the football team!"'
(Ally Brown, London)

At the end of the rhyme, the skipper has to run out of the turning rope. If that wasn't hard enough, in some games the rope is turned twice for one jump – known as 'Doubles' or 'Bumps'.

Skipping is such a versatile game that even quite a large number of skippers can take part. They either take turns or gradually join other

skippers jumping to such rhymes as this one where skippers have to run in when their birthday month is called:

All in together girls,
Never mind the weather girls,
When I call your birthday
You must jump in.
January, February, March,
April, May, June, July,
August, September, October,
November, December.

Anyone missing the call or fouling the rope is either out of the game or has to turn the skipping rope. There was often a line at the end

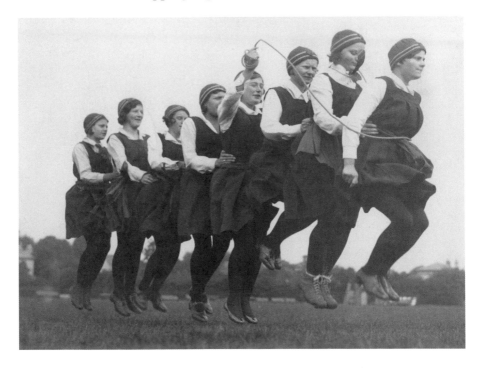

of a rhyme to indicate when skippers should run out of the rope, for example, 'O-U-T spells out so out you must go!'

'Double Dutch' involves two turning ropes – one going under and one over. Players have to run in and out of the ropes and perform a variety of moves such as crossing and uncrossing legs or making bunny hops. It requires a high level of skill – and energy!

Variations: French or Elastic Skipping – a length of elastic is used instead of a rope.

Spuckle

A game that used to be played inside the classroom rather than outside as polished floorboards were an essential element.

The 'spuckle' is a blackboard rubber and contestants slide this (felt side up) along the floorboards towards an area where chalk lines have been drawn across with points (for example, 5, 10, 15, 25, 50, 100 etc) marked out. Wherever the spuckle stops is the score for that player. The player with the highest score wins.

'This took place at St Augustine's Abbey School, Ramsgate (known to the inmates as St Disgusting's Shabby). . . The pastime was frowned upon by the authorities so look-outs had to be posted to alert the players to the master's return and there were many narrow squeaks which made it all the more exciting to the boys concerned.'
(Tim Fagan, Bekesbourne, Kent)

An ideal playing area used to be the aisle between rows of desks which kept the spuckle on course, and the points were marked out in front of the teacher's desk.

Statues

One player is chosen to be 'It' and he stands with his back turned to the rest of the players. Then everyone (except It) rushes around keeping a watchful eye on the person who is It because as soon as he turns round everyone has to freeze. This usually leads to some comic results as players have to hold the most awkward positions until released when the word 'Go' is shouted. Anyone who is caught moving even a muscle is out of the game.

Stoolball

A game rather like rounders (*see* page 74) but played with a bat shaped like a wooden frying pan and with a square of wood as a wicket. It is supposed to have originated in Sussex in the 14th century and been invented by milkmaids who used their stools as wickets. It is mainly played in the southern counties of England.

'We played stoolball on the village green but I'd only play when the others agreed to use a tennis ball. Having a hard cricket ball flying towards your face and only a piece of round wood to defend yourself was truly scary!' (Betty Ross, Arundel, West Sussex)

Tag

The most famous and universal of all chasing games. One player is selected to be 'It' and they chase the other players trying to tag them by touching them on the shoulder. Anyone caught becomes It, but they are not allowed to immediately touch back the player who has caught them who often shouts out 'No returns!' to make sure.

The game is usually played within a defined area and the chaser is sometimes taunted with mocking rhymes like:

Ha, ha, ha, he, he, he,
Can't catch me for a bumble bee!

Variations (just a small sample): Chain He: Two players join hands and try and catch the other players. Anyone they tag also links hands and eventually a chain is formed.

Charge: A game like British Bulldog but not as rough as players are tagged by just a touch.

Hopping He: Everyone has to hop.

Kiss Chase: Anyone caught is kissed.

Off Ground Touch (Mary, I'm on High Land): You can't be tagged if your feet are off the ground – standing on a seat, tree trunk etc.

Pairs He: Two players join hands (as in Chain He) and try and catch the others. When they tag someone they join hands with the pair, but when a fourth is caught they split into two pairs and so the game continues.

Shadow He: Players are tagged when their shadow is stepped on.

Stuck in the Mud: Two catchers are selected; anyone tagged has to stand still until released by a 'free' person.

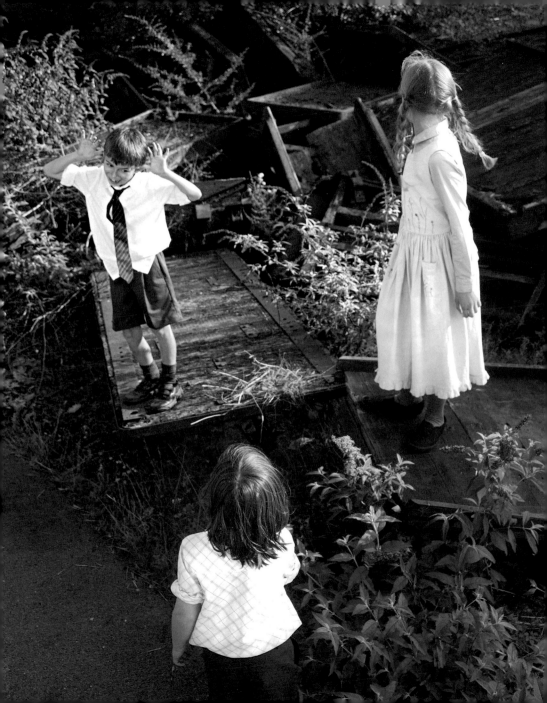

Tag variations continued: Tig No Tell: No one has a clue who is the chaser.

Touch Colour: The person selected as It chooses a colour that gives immunity. Anyone wearing or picking up something of that colour can't be tagged.

Touch Wood: Touching wood means you cannot be caught.

Tree He: You are safe if you climb up a tree.

Underground Tig: Once someone has been caught and touched they have to stand still with their legs apart. They can be released by a brave person crawling between their legs.

Walking He: No player can run.

Also known as: Catch; He; It; Tig; Touch

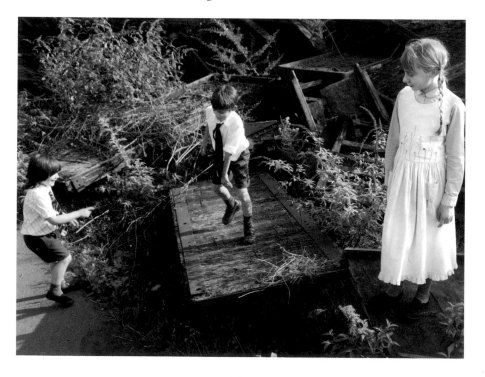

Tile Off

Two teams are chosen with between three and ten players in each. They toss for which side will be 'in' first. At the start of each innings a block of 'tiles' are stacked in the middle of a marked circle of 12 – 15ft in diameter. The tiles are rectangular wooden blocks, typically about seven in number, which are about 4in x 4in x 1in. A tile is also the scoring measurement of the game.

Members of the out team are not allowed in the circle and, initially, the in team has to stand outside it too. To start the game, one person from the in team stands just outside the circle and throws a tennis ball at the pile of tiles, attempting to knock some of them to the ground. If he fails to hit the pile after a defined number of throws (about four) he is immediately deemed to be out and can take no further part in the innings. It is then the turn of another member of the in team to try and break up the pile. These turns continue throughout the innings but are interrupted whenever one or more tiles are knocked off the pile.

'One good aspect of the game was that the more talented players on the in team could not monopolise the scoring for long periods as often happens in cricket.'
(David Greene, Harlow, Essex)

When that happens, all members of the in team try and rebuild the pile. However this is risky because the ball is picked up by someone from the opposing team who tries to hit any members of the in team with the ball – thereby eliminating them from the game. Any player holding the ball has to stand still and can either aim at an opponent or pass the ball to a team-mate who might be in a better position.

Sometimes, if an in team player makes a clean catch of a toss from an opponent they are not out and can throw the ball immediately in any direction. This allows plenty of time to reassemble the pile of tiles but it is a rare occurrence because out team members often roll the ball to each other or throw it to reach the ground just before hitting the target.

Whenever the pile is successfully rebuilt, the in team score one tile. Surviving members of the in team then start another round and the innings only ends when there are no members of the in team left.

Tin-Off

A starting point or base is first selected – usually a drain cover. A tin is placed there and one of the players is chosen to be the 'guard', 'canner' or 'denner'. He kicks the tin as far as he can while the rest of the players run off and hide (usually within an agreed boundary). The canner retrieves the tin and returns to base yelling 'Tin-Off' as he places it back in position and goes off in search of the other players. As soon as he spots someone, he rushes back to put his foot on the tin

and shouts out the name of the person he has seen. That person has to come out of hiding and go and stand in the base. However, they can be freed if any uncaught player runs into base and kicks away the tin.

Variations: Also played with a football instead of a tin.

Also known as: Kick the Can; Tin Can Jerky; Tin Can Tommy; Tin-the-Block

'When the guard found someone he uttered the immortal line, "Come oot yer blocked" and tapped the block/tin to confirm the "kill".' (Bob Buyers, Newcastle upon Tyne)

Tip Cat

A game that needs no special equipment or pitch and which has the added allure of danger! However, it is rarely played now – probably because the risk to nearby windows (as well as life and limb) is just too great!

The 'cat' is a piece of wood about 4in long and 1½in wide tapered at one end. It is placed on a raised surface, usually a pile of bricks, about a foot high. It is then hit downwards with a wooden stick or a flat piece of wood making the cat jump in the air; then it is struck sideways just like a cricket ball. The score is the number of strides that can be made to where the cat lands. Another player then attempts to better the score; if he does then the first striker is out, but if they fail the first striker continues with his innings. If the cat is caught by an opponent then the striker is also out.

Variations: Sometimes a circle of about 6ft in diameter is drawn round the block. If the striker misses the cat he can have as many goes as necessary to lift it into the air. If they then miss hitting it sideways and the cat falls within the circle, another attempt is allowed. It is also possible to play on your own as a test of skill.

Also known as: Peggy; Piggy

Tug of War

A rope or a bit of washing line are the essential ingredient for this trial of strength. Nowadays tug of wars are usually officially organised but in the mid-20th century they often formed part of a street game. A chalk line is drawn (or a cap put down) to mark out the centre and two teams selected. The object of the game is to pull the rival team over the centre line and so score a win.

Two Balls

Two tennis balls and a high wall (with no windows!) are all you need for this game. Stand a few yards from the wall and throw the first ball against it; as it bounces back, throw the second ball and catch the first ball. Immediately throw the first ball again while catching the second and keep juggling in this fashion for as long as possible. When you get proficient at this, keep the balls going while chanting:

Plain sey, Mother Brown, plain sey, Mother Brown,
Plain sey, plain sey, plain sey, plain sey,
Plain sey, Mother Brown.

If you can get to the end without dropping any balls, you then go on to, 'One hand, Mother Brown, etc' which involves catching the ball with one hand on the 'one hand' part of the rhyme and both hands for the 'Mother Brown' part. This is followed by, 'Other hand, Mother Brown, etc' using the other hand and again both hands for the 'Mother Brown'. If you get this far without making any mistakes, you then do, 'Drop sey, Mother Brown' – allowing the ball to bounce to the ground once before you catch it. The final part is, 'Twisty, Mother Brown' – twisting in a complete circle while the ball is bouncing on the ground and then catching it.

Up the Street and Down the Street

A popular ring game that dates back to at least the 18th century. It is probably far older than that and is one of a number of games where the participants have to select a marriage partner. The players all join hands and then walk or skip round in a circle singing:

Up the street and down the street,
The windows made of glass.
Isn't Sally Smith a nice young girl?
Isn't Freddie Jones as nice as she?
They shall be married if both agree.

The named couple go to the centre and dance together, and the game continues with other couples being paired off.

Usky-Bum, Finger or Thumb?

This was an immensely popular game throughout the country from the 1920s to the 1960s. It's far too rough and dangerous to be an accepted pastime today but 50 years ago boys (in particular) loved it.

The game requires two teams of five or six players. They decide by some selection procedure which team will be 'in' first and do the jumping. One boy from the other side then has to stand with his back against a wall or fence supporting the rest of his team who stand in a line behind each other with their heads between the shoulders or legs of the person in front of them – imagine a rugby scrum position but in a straight line and look at the photograph for a clearer idea!

One by one, the rival team then runs at the line from behind and leapfrog onto the backs of their opponents. The first to go has to be light and agile enough to get as far along the backs as possible so there's room for his team-mates. If the scrum collapses then the jumping team wins and has another turn to jump; if it remains up even with all the other team astride then the leader of the jumping team holds up one of his fingers and asks, 'Usky-bum, finger or thumb?' The leader of the other team has to guess and, if they are right, their team get a chance to jump.

'Scrabbling along bent backs was not allowed. Should an early jumper jump short it often meant the last man down receiving most of the jumping team. They would be clinging on for dear life and often one member would fall off or a part of him touch the ground. If that happened the teams changed places.'
(C J Beavor, Birmingham)

Variations: The first player in the team making the backs doesn't stand with his back against the wall or fence but bends over facing it in the same way as the rest of his team-mates.

Also known as: Finger, Thumb or Rusty Bum?; Hi Jimmy Knacker; Husky Fusky; Jeremiah; Jump the Nagger; Loppakitty; Montykitty; Ton Weights; Weak Horses

'This game was banned at the boys' grammar school I attended but I'm not sure whether this was on safety grounds or because the fence, against which we played, kept being broken.'
(John Drabble, Farnborough, Hampshire)

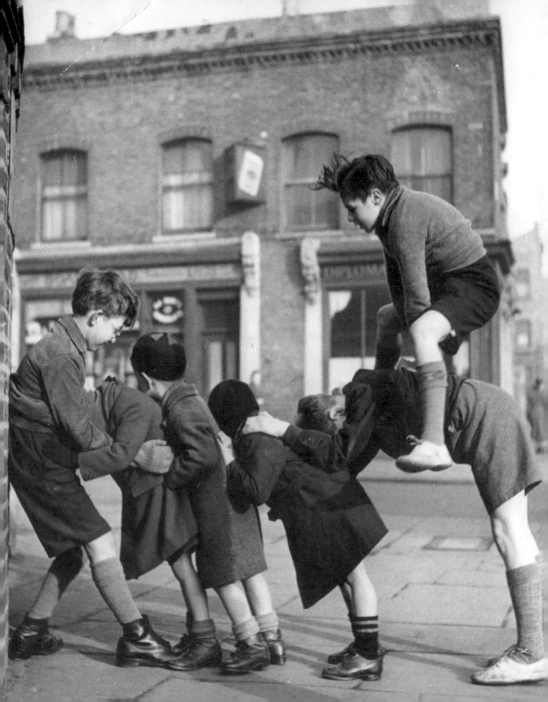

Wall to Wall

Like many games, players have to risk crossing a designated area without being caught. This game is best played where there are two walls on either side of a street, although two chalk lines can be marked out instead. One player is chosen to be 'It' and they take up a position between the two boundaries. The rest of the players stand one side and the object of the game is for the players to rush across to the other wall or boundary without being caught by It. Anyone caught has to go in the middle and help with the catching.

Variations: Yorkshire Pudding or Half Loaf: everyone has to hop.

Also known as: Cross Channel; Den to Den; Fox and Hounds; Poison

What's the Time, Mr Wolf?

One player is selected to be 'Mr Wolf' and he walks off while the rest of the players follow behind. They call out, 'What's the time, Mr Wolf?' and he chooses a time such as '11 o'clock' in answer. He doesn't turn round to reply and the question is asked again with the group gaining in confidence and getting a little closer to him. The question and answer routine goes on until Mr Wolf judges that someone is quite close to him. Then, when the question is put again, he swings round sharply, yelling out 'Dinner time!', and everyone flees in horror. Mr Wolf gives chase and anyone he catches then becomes Mr Wolf in the next game.

Also known as: What's the Time, Mr Fox?

'An amazing amount of tension would develop as you got closer to the "Wolf".'
(Terence Moore, Hackett, Canberra, Australia)

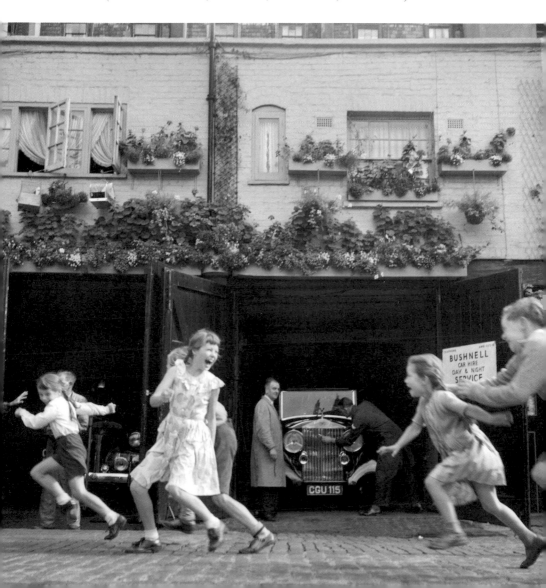

Whipping Tops

Simple wooden tops often decorated with coloured bands were particularly popular in the 1920s–40s. They were set spinning by a whip or stick with a length of string attached, producing a

kaleidoscope of colour and a pleasing humming noise. The surface of the top was often grooved to make it easier to spin. Small racing tops could move really quickly across the ground and it was great fun running races along the street with them. Some tops were made of metal and they came in a variety of shapes and sizes.

'It was the custom to wedge the top in holes of the cast-iron grids at the foot of the street's plane trees.'
(Kenneth Lorberg, Orpington, Kent)

Just like diabolos and yo-yos, you can do all sorts of tricks with a spinning top, such as placing your hand next to it and making it run across your hand and up your arm.

'Alas some poor things could never spin their tops properly and were reduced to sticking them in holes, and then a good sharp clout would send them spinning. We despised such methods.'
(Cyril Francis Campbell, Liverpool)

Witch's Ring

A small circle is marked out in the centre of a playing area – or a hoop put down. One person is selected to be the 'Witch' and she crouches in the circle or hoop while the other players walk round her. The Witch slowly rises up from her crouched position until, reaching full height, she shouts, 'Here I come!' and dashes out to try and catch the others in the group. Anyone she catches is turned into something – a windmill for example – and that player has to freeze in a suitable pose. Then the whole procedure begins again until all the players have been caught by the Witch.

Variations: Instead of freezing, the players are allowed to move around miming the thing they have been turned into.

Also known as: Hunter and Rabbits; Jack in the Box

Yo-Yo

What went into space aboard the Atlantis in 1992? What do you use to walk the dog, hop the fence, loop the loop and sleep? What did Napoleon use to relieve stress on the eve of battle? Which toy have two presidents of the USA played with in public? The answer, of course, is a yo-yo!

Two discs with a long string sandwiched between them provide all sorts of games and hours of enjoyment. And they have done for literally thousands of years. Stone yo-yos, often decorated with paintings of gods, goddesses or mythological beasts, were played with as long ago as the 6th century BC in Greece, and there is also evidence that they were popular in ancient Egypt and China. They were played with in India in the 18th century and before long the craze had spread to Europe. They weren't called yo-yos at this time but went by names such as 'bandalore' and 'l'emigrette'. They were usually made from wood but metal, glass and ivory examples are also known.

The word 'yo-yo' apparently means 'spring' or 'come back' in Tagalog – the native language of the Philippines – where yo-yos have long been popular playthings. There was a highly unlikely theory that they had derived

from a native weapon – a huge rock tied to a long rope which could be thrown at enemies and then pulled back. In the early 20th century a Filipino immigrant called Pedro Flores began manufacturing wooden yo-yos in the USA where they quickly became popular. He was bought out by D F Duncan Senior in the 1920s, who trademarked the name Yo-Yo. The company also looped the string round the two discs so the yo-yo could do numerous tricks such as sleeping (where the yo-yo stops at the end of

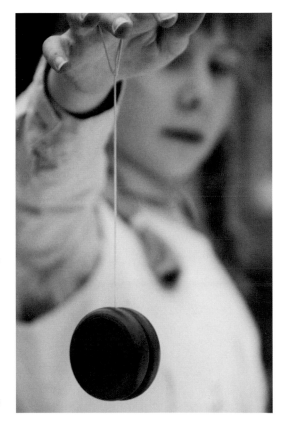

the string but still keeps spinning), and walking the dog (making the yo-yo sleep and then letting it roll along to ground while you hold the end of the string). In 1955 the first plastic yo-yo appeared and the popularity of yo-yo games has literally gone up and down ever since.

The standard yo-yo is called an 'imperial' but there is also a 'butterfly' version where the shaped discs are reversed. This makes certain tricks easier to perform.

Zebra, Zebra, Tiger

One person is selected to be 'It' and everyone else sits down in a circle. The person who is It then walks round the outside of the ring gently tapping each person on the shoulder and saying 'Zebra, zebra'. Eventually she taps a shoulder and says 'Tiger'. That person has to leap up and chase the girl who is It round the circle trying to beat her to the empty space in the circle. If she fails, then the Tiger becomes It in the next round of the game.

Also known as: Duck, Duck, Goose

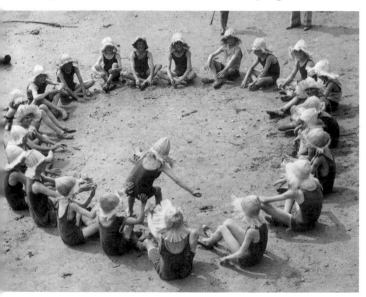

'It has been an interesting exercise thinking back over my childhood and realising how much I do actually remember and also comparing my experiences with those of today's children who have so much but who, I think, are in danger of missing out on some of the essentials of childhood.'
(Mary Folley, Leigh-on-Sea, Essex)

Index

Acknowledgements

The publishers would like to thank the many people who have made a great contribution to this book, in particular:

Dr Aileen Adams; Miss C Aston; Audrey Ball; Mr K Banyard; Christine Bartlett; Carole Beaty; C J Beavor; Ally Brown; David Butcher; Robert Buyers; Peter Calviou; Adèle Campbell; Bernard Campbell; Heather Catterfeld; Mary Dennis; John Drabble; Anna English; Tim Fagan: Peter Fleming; Mary Folley; Sylvia Fryatt; Mike George; David Greene; Mrs S Hawley; Christopher A Heath; J Hicks; Dennis Hodsdon: Joan Hodsdon; Rachel Howard; Kenneth Lorberg; Mrs M Manson; Ron Masters; Lindy McKinnel; Mrs A P Mead; Terence Moore; Mrs J S Newman; René Rodgers; Betty Ross; Margaret Simkin; Sandra Taylor; Joseph Thompson; David Thornton; Jeremy and Lynda Treliving; Mr A Turnbull; Mr T Vaughan; Claire Walker; Mrs M Waller; Jane Whalley.

We are very grateful to James O Davies for taking all the superb colour photographs in this book – and to Jimmy Campbell, Megan Lenthall, Mimi Richardson and Alexis Tessier who had great fun playing the games. Colleagues in English Heritage have also helped and we would like to thank Charlotte Bradbeer, Dr David Jones and Peter Williams.

Picture Credits

The publishers would like to thank the following people and organisations listed below for permission to reproduce the images in this book. Every care has been taken to trace copyright holders, but any omissions will, if notified, be corrected in any future edition.

Unless otherwise stated all images are reproduced by kind permission of Getty Images.

Photographs appearing on pp 2, 5, 6, 7, 8, 11, 18, 24, 25, 26, 37, 38, 44t, 45, 49, 57, 58, 66, 67, 77, 83, 84, 86, 96, 97 are © English Heritage. NMR. Photograph on p43 © Fiona Powers.

Further Reading

Burton, Anthony *Children's Pleasures: Books, toys and games from the Bethnal Green Museum of Childhood.* London: Victoria & Albert Museum, 1996

Edmundson, Joseph *The Pan Book of Party Games.* London: Pan Books Ltd, 1958

Greenaway, Kate *Kate Greenaway's Book of Games.* London: Chancellor Press, 1986

Hall, Godfrey *Games.* Hove: Wayland, 1995

King, Karen *Oranges and Lemons.* Oxford: Oxford University Press, 1985

Opie, Iona and Opie, Peter *Children's Games in Street and Playground.* Oxford: Oxford University Press, 1984

Opie, Iona and Opie, Peter *The Singing Game.* Oxford: Oxford University Press, 1985

Thornton, David *Great Leeds Stories.* Ayr: Fort Publishing, 2005

Wales, Tony *Long Summer Days: Games and pastimes of Sussex children.* Horsham: Field and Furrow, 1983